HOLLYWOOD PORTRAITS

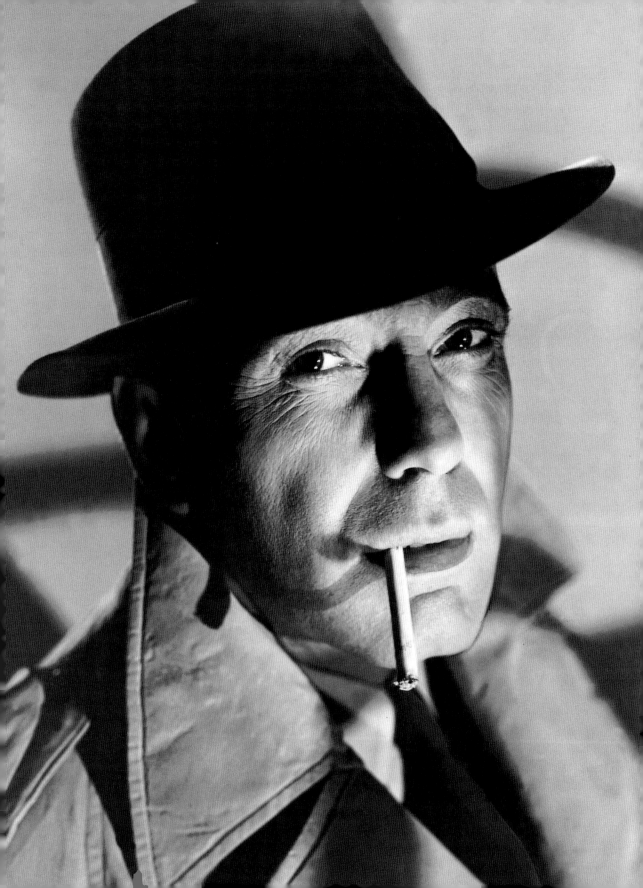

HOLLYWOOD PORTRAITS

CLASSIC SHOTS AND HOW TO TAKE THEM

ROGER HICKS AND CHRISTOPHER NISPEROS
PHOTOGRAPHS FROM THE KOBAL COLLECTION

Amphoto Books
An imprint of Watson-Guptill Publications
New York

To Don Nibbelink, who, in my opinion, is one of the finest technical editors ever employed by Eastman Kodak, and whose writings ignited my passion for high quality portraiture in black and white, and to Wallace Seawell, a great Hollywood photographer whose commitment to technical excellence made his work stand apart from his peers. He has been largely unsung, but never unknown, and he remains an excellent example to follow. – Christopher Nisperos

First published in the United States in 2000 by
Watson-Guptill Publications
a division of BPI Communications, Inc.
770 Broadway
New York, NY 10003

Library of Congress Card Number: 00-103119

ISBN 0-8174-4020-8

This book was designed and produced by
Collins & Brown Limited
London House
Great Eastern Wharf
Parkgate Road
London SW11 4NQ

Editorial Director: Sarah Hoggett
Editor: Ian Kearey
Technical Consultant: Frances Schultz
Designers: Alison Lee and Steve Kent
Illustrator: Kate Simunek

Manufactured in Hong Kong

CONTENTS

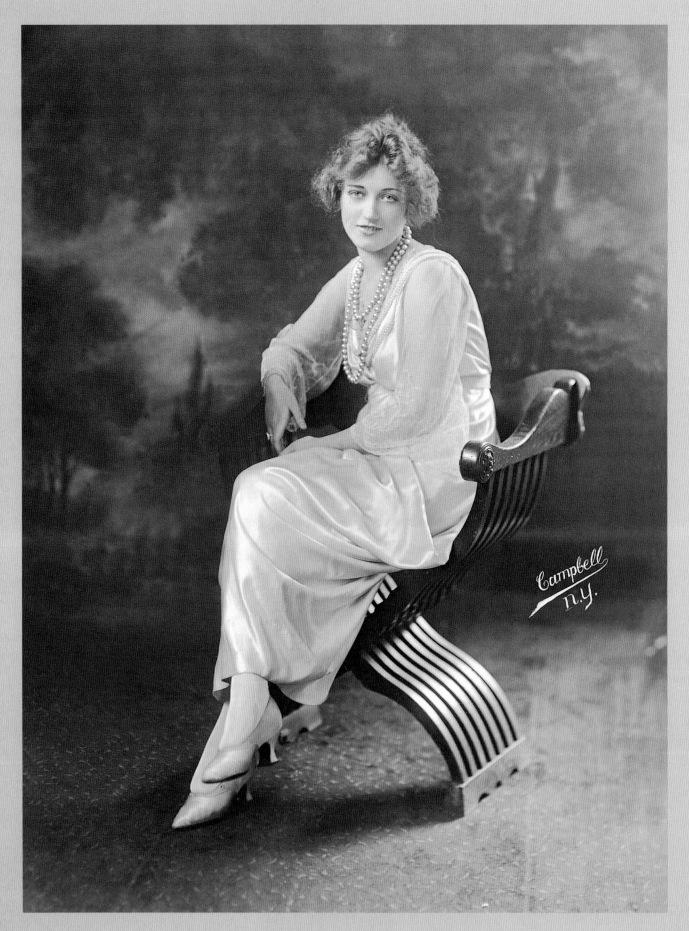

Campbell
N.Y.

INTRODUCTION

Even today, many decades after the heyday of Hollywood portraits, these iconic images still fascinate countless people: movie lovers, connoisseurs of beautiful women and handsome men, and, of course, photographers. As far as we are aware, however, no book has hitherto attempted to analyze the lighting that was used for specific Hollywood portraits. There have been plenty of books of portraits and books about the stars and books about portrait lighting; but the three strands have not been drawn together.

It is, of course, next to impossible to reconstruct exactly how a particular shot was lit, perhaps 70 years ago. We do not claim infallibility or anything like it. Indeed, there were occasions when we could not agree between ourselves on exactly how a particular picture was lit. We do, however, believe that our analyses are pretty close, so that anyone reading this book will find themselves significantly better equipped to shoot Hollywood-style portraits. The reader should also be better able to understand what cannot readily be replicated, whether for technical reasons or because of the very heavy Hollywood reliance on retouching. In the course of explaining all this, we hope that we may also dispel some of the myths and misunderstandings surrounding the technical aspects of these portraits.

The vast majority of contemporary magazine articles about the stars were, of course, written to bolster the myths behind the images, so the pictures were often described as unretouched and without make-up. This may occasionally have been true, but as most studios employed many more retouchers than photographers, it clearly was the exception rather than the rule. Nor should one ignore the fact that lighting plots may sometimes have been guarded as a trade secret or the simple truth that many photographers, then and now, take a malicious delight in misleading the technically ignorant, just for the fun of it. Although it is true that

Early Hollywood portraits resemble studio portraits of the nineteenth century, with soft, daylight-style lighting. This is Marion Davies, 'star in Select Pictures,' which dates it to 1918; by 1919 the credit would have been to Cosmopolitan Pictures, formed by W. R. Hearst to promote Ms Davies, not to the Selznick/Zukor studio. (Campbell Studios, New York.)

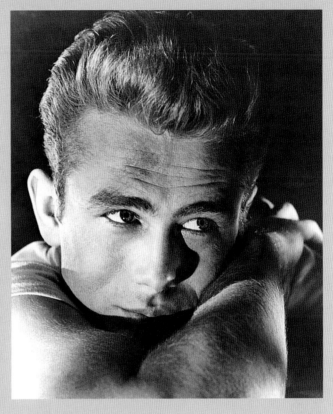

With the decline in the use of 8 x 10 in. (20.3 x 25.4 cm) cameras, technical standards (which were never very high in Hollywood anyway) tended to decline still further. This portrait of James Dean might be rejected by the average camera-club competitions secretary today, although some of the quality loss may be attributed to its being a second-, third-, or fourth-generation copy. (Photographer not credited, no date.)

plenty of photographs purport to show the lighting either for a movie set or for a still, when it is possible to compare the picture of the lighting set-up and the final image, it is often abundantly clear that the set-up illustrated bore no relationship to the actual lighting used; all contemporary illustrations of lighting set-ups should be treated with some reserve.

This is, however, part of the fun of re-creating the Hollywood look today. There is an element of detective work in it; a certain radar is needed for detecting wilfully misleading or ill-informed statements, ancient or modern; and there is no substitute, once you think you have understood what is needed, for actually trying it for yourself. We hope that this book will make your quest easier.

This picture of Elmer Fryer photographing Joan Blondell in *Lawyer Man* (1932) gives a good idea of the type of camera used: a big, wooden view camera with a very long extension. The lights in shot may or may not represent the actual lighting set-up. Note also the well-supported pose. (Photographer not credited, 1932.)

The diacetate film base of countless Hollywood negatives deteriorated badly in 30 or 40 years, and triacetate bases are not a great deal better. Modern polyester bases are more stable, but they did not come into widespread use for general camera films until the 1960s or even 1970s. (Photograph of Norma Shearer, Eric Carpenter, 1941.)

CAMERAS, LENSES, FILM, AND RETOUCHING

The classic camera for a Hollywood portrait in the 1930s and 1940s was 8 x 10 in. (20.3 x 25.4 cm), typically Ansco, though Kodak and other marques were also used, and reducing backs were often used on 11 x 14 in. (28 x 35.5 cm) and still larger cameras. As late as the eve of World War II there were still many who reckoned that a 2x enlargement from 4 x 5 in. (10 x 12.5 cm) would show markedly inferior grain and sharpness to an 8 x 10 in. contact print. They seem to have been right: in the 1910s and 1920s, half-plate (4¾ x 6½ in./12 x 16.5 cm) was popular, and the pictures do not stand enlargement well, though primitive pyro-soda developers may have contributed to this.

Even in 8 x 10 in., however, photographers tended to shoot large numbers of pictures in a session, a minimum of 10 or 20, and often many more. They also kept obvious failures. For example, Jean Harlow had a weak right eye, and in a number of pictures her eyes are looking in different directions. You might think that Harlow herself, or the photographer or MGM, might have thrown these out; but they didn't. There are also plenty of pictures in which the plane of focus is some distance from where it should be. Of the literally thousands of pictures we went through for this book, a surprising number – perhaps as many as a quarter – would be regarded as technical failures by a critical modern photographer. Leica cameras were used in Hollywood as early as 1932 or so, and after the war 4 x 5 in. (10 x 12.5 cm) roll film and 35mm came into much wider use. As a result, the classic look was all but lost.

Lenses

The usual lenses were long and often surprisingly fast for their focal length, a combination that makes it far easier to focus quickly and positively than is possible with shorter or slower lenses. For instance, the lens data on Hurrell's camera, shown on page 32, is an 18 in. (45 cm) f/5.6 Cooke Series VI. From those rare instances when exposures are known, however, it seems that f/16 was a common working aperture, presumably in the interests of depth of field. There was surprisingly little change in the types of lenses used from the earliest days of the movies to the eve of World War II, and, indeed, beyond: probably the majority of lenses in use for still photography throughout this period had been introduced in the first decade of the twentieth century, or late in the nineteenth century.

Sharpness, or the lack of it, was a matter of fashion, not of technical necessity, and in the early 1930s deliberately fuzzy pictures were going out of fashion. Many lenses allowed a degree of soft focus to be introduced, however, via deliberate spherical aberration. This does not give the same effect as lack of focus, but rather surrounds each point of light with a halo. This explains the 'glow' of many Hollywood portraits. The smaller the format, the harder soft focus is

to control or predict: it is easiest to control when working same-size on a big ground glass. Another reason for the 'glow' was that uncoated lenses are flary. This lightens shadows and can also mimic true soft focus. After World War II anti-reflection coating became all but universal, though some photographers stuck to their uncoated lenses because they considered coated lenses 'too sharp' or 'too contrasty.'

Film and Development

In about 1931 Eastman Kodak introduced Eastman Super-Sensitive Panchromatic Film, known to its friends as SS Pan. This soon displaced ortho film in the majority of Hollywood studios, as its enhanced red sensitivity meant that it did not render red lips so dark or complexions so rosy. Super-XX, with still better red sensitization, replaced SS Pan in general in the late 1930s, but it was still rated ⅓ stop slower to tungsten light than to daylight: insofar as comparisons are possible, about ISO 80 and 100 respectively. With all of these films, halation – the tendency for a halo to form around light sources and highlights – was more marked than with modern films.

In the 1920s and 1930s films and plates were often underexposed and overdeveloped by modern standards, resulting in thin, contrasty negatives. Later, more exposure was given, but it was still not generous, and development was reduced; this meant that the negatives were still thin, but less contrasty. The negative in the above right image was presumably regarded as reasonable – why show a bad negative, after all? – but it looks very thin by modern standards.

By modern standards, this negative of 'MGM Starlet Virginia Grey' is hopelessly underexposed, but if you look at many of the pictures in this book, shadow detail is conspicuous by its absence. (Photographer not credited, no date.)

Retouching

Although some Hollywood portraits are not retouched at all, many more are – very heavily. This was done on the negative: comparatively easy on an 8 x 10 in. negative for contact printing and not too difficult on a 4 x 5 in. negative for enlargement, but next to impossible on roll film. Not just minor flaws in the complexion were taken out: complexions were completely remodelled with a soft pencil, backgrounds were cheerfully 'blown out' with the airbrush, and 'hammer and chisel' corrective retouching was applied to faults on the negative. The retouching around Marlene Dietrich's fingers (right) is a good example.

Retouching on 8 x 10 in. negatives is actually easier than one might expect, though there are a few tricks worth knowing. Use a soft pencil. Don't press too hard or you will end up with shiny areas that won't take any more retouching. Work with tiny ticks, scribbles, or figures of eight: don't try to follow lines too clearly. Fix the retouching with steam from a kettle, but remember to let the negative dry fully afterwards.

When you are making contact prints, especially contact prints that are unlikely to be examined closely, you can get away with much less subtle retouching than is feasible for enlargement – the more so as there is no Callier effect (light scattering during enlargement) in a contact print. The whole of this picture appears on page 79.

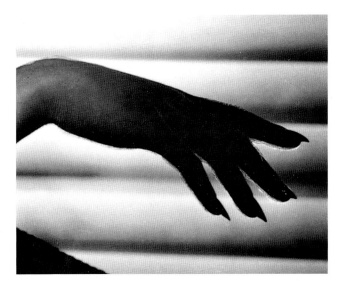

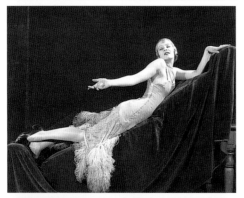

Ronald Reagan and his suit tussle for dominance in this picture, but it shows how a basically ordinary portrait can gain dynamism via a tilted camera. ('Scotty' Welbourne, 1940.)

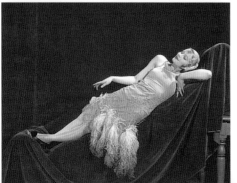

POSES, PROPS, AND MAKE-UP

By and large, portraiture with 8 x 10 in. cameras requires poses that are easy to hold. This is because there is a long gap between focusing and taking the picture. After focusing and composing the picture, the photographer must close the shutter, insert the film-holder, pull the dark-slide, and then fire the shutter. This must all be done without moving the camera and without the subject's moving. What is more, small apertures and slow films often meant long exposures, even with powerful lights: exposures of between $\frac{1}{10}$–$\frac{1}{2}$ second were commonplace. Keeping the camera from moving was not all that difficult: some of the camera stands that were used in the pre-war period look like a flight of steps for boarding an airliner, rather than a tripod. But keeping the subject from moving was another matter. As soon as you start to look for this, you realize just how many poses were chosen specifically because they almost locked the subject into one position. Actresses recline in languid poses where they have only to relax and let the chaise longue support them; actors lean on solid, immobile props so that they cannot sway to and fro.

Of course, there were actors and actresses who could hold the most demanding poses for long periods, and on occasion, you can see traces of subject movement where the hem of a dress has moved during the exposure, as in the bottom image on page 16.

Props

Perhaps the most commonly encountered prop is one of the smallest. In an era when tobacco is vilified, the endless parade of cigarettes and (occasionally) pipes is almost shocking – but it is not unrealistic to say that one of the quickest ways to create a Hollywood ambience is to hand your subject a cancer stick. Cigarettes also solve the perennial problem of what to do with a subject's hands; and despite decades of rational, scientifically based propaganda to the contrary, there is no doubt that cigarettes did indeed have a certain glamour in Hollywood, if only by association with the stars.

The main things to remember when dealing with all other props are that they should be appropriate, that they should not be shabby (unless that is part of the picture), and that they should not dominate the subject.

The first can be problematic if the photographer wants to create a certain image, and the subject is unhappy with the chosen props. Many people today cannot handle a cigarette with conviction, and the same is true (and has always been true) of guns: among the many pictures we did not use in this book was one of Gary Cooper, looking as

One of these pictures of Greta Garbo in *The Temptress* (1926) is credited to Bud Longworth, another to Ruth Harriet Louise. Regardless of who actually shot them, they illustrate two things. First, a recumbent subject is easier to keep in focus, and second, Hollywood photographers shot far more 8 x 10 in. film per session than we would today regard as believable.

if he would have been happier holding his revolver at arm's length with a pair of tongs. The most successful portraits make use of something that the photographer has already noticed to be characteristic of the subject: a favorite bangle perhaps, or eyeglasses (even a monocle), or a walking-stick. Some re-created Hollywood portraits, too, are undermined by anachronisms: a digital watch, for example, can be all too obvious.

Shabbiness is particularly apparent in still pictures, possibly because we can examine the picture so carefully. In movies, where a prop may be on the screen for only a fraction of a second, and where our attention is distracted by the main subject, shabbiness is much less of a problem.

As for props dominating the subject, both guns and cigarettes can provide good examples if the subject is not at home with them, but equally, a face or human figure will almost invariably dominate even the most obtrusive furniture, flowers, or plaster statuary, unless the lighting is exceptionally incompetent. Millions of years of evolution have conditioned us to scan the landscape for friend or foe, and we do the same in a portrait. The subject's relationship with the props is what matters. If there isn't one, or if the relationship is uncomfortable, then the picture won't work.

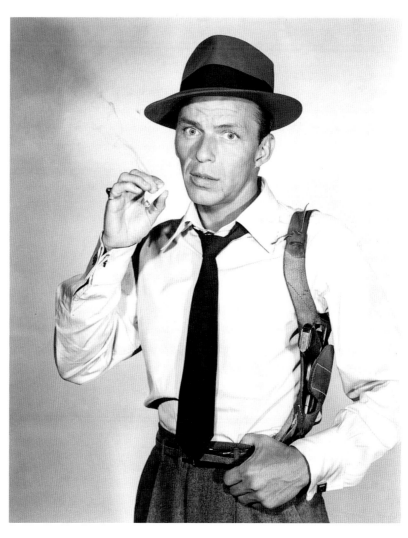

A haunted-looking Frank Sinatra has one classic Hollywood prop in his hand and another in a shoulder holster in this 1954 United Artists picture for *Suddenly*. (Photographer not credited.)

Make-up

Many magazines dating from the 1930s, and some of the photographers, swear that no make-up was used. This may have been true sometimes, but most of the time it is clearly untrue. We believe that sometimes they were simply lying in order to preserve the myth that the stars were perfect and that on other occasions they did not count 'street' make-up as make-up at all. In many pictures, use has clearly been made, at the very least, of transparent powder to kill highlights, and it is possible that a little rouge was used for shaping. Almost invariably, too, the women were wearing eye make-up, even if no other make-up is apparent, although in all fairness, foundation ('pancake') is rarely used. It also seems most unlikely that many of the female stars could have mustered the kind of eyelashes that appear in so many pictures unless they had some help.

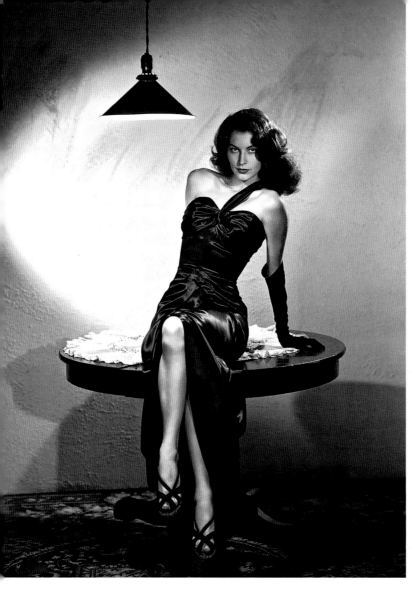

Put not thy faith in lights that appear in shot. In this photo of Ava Gardner, taken by Ray Jones in 1946 for *The Killers*, the multiple shadows of the table reveal that the overhead lamp in shot is almost totally irrelevant.

There is, however, the point that very heavy retouching may have been easier on un-made-up faces, and there are even a couple of references to oiling the skin for photography – exactly the opposite of what any modern photographer would normally do.

LIGHTING BASICS

In the early days of movies, and often throughout the 1930s and 1940s, movie studio lighting was used for portraiture: big Mole Richardsons and Kliegs. Some of these were massive: spots a yard across were not unknown. There was a whole vocabulary of these lights: 'inkies' or 'inky dinkies' were small focusing spots; 'kegs' were barrel-shaped spots, typically 500W; 'soft lights' were big, rectangular lights similar to those in the picture on page 47; and 'scoops' were lamps in reflectors 18 or 20 in. (46 to 51cm) across.

Unfortunately, the vocabulary was not entirely standardized. Often, too, the names of particular manufacturers' individual lights were used as generic terms, sometimes to the chagrin of the manufacturers. Descriptions of power (in kW) were, however, quite standard: a '2K' is 2 kilowatts, '5K' 5 kilowatts and so forth. The biggest lamps in common use were 10K. Even after still lighting became divorced from movie lighting, focusing spots remained a very popular way of lighting portraits. These were almost all Fresnel spots with a lens in front of the lamp, rather than the 'open-face' variety more common today, when the focusing effect is varied by moving the lamp relative to a reflector.

Lighting Distances

Because movie lights were so enormously powerful, they were often used at quite large distances in order to avoid frying the subjects, and 'Klieg eye' (in effect sunburn of the retina caused by the very high UV content of carbon arcs) was a recognized hazard of early movie acting. The extremely high UV content of carbon-arc lights was quite important, as it meant that an unfiltered exposure was disproportionately made by blue and violet light, rendering lips dark and making rosy complexions look far more dramatic than they were.

If more conventional tungsten lighting was used, working distances were smaller, but they may still have been greater than is regarded as normal today: by the end of the twentieth century, people seemed more willing to have huge lights very close to them. In general, it is

easier to work with close lights than with distant ones, because the effects change more rapidly, but there are some techniques, such as very hard shadows, that require either special projection spots or greater working distances.

Booms

Supporting lights on 'booms' or cantilevers was a common way to light from overhead or almost overhead, and some photographers used two, three, or even more boom lights or hung their lights from permanent overhead fittings, as on a movie stage. It can be difficult to duplicate this effect without booms, as the lighting stands will appear in the picture. Unfortunately, a conventional boom is around 10 ft (3 m) long, so to use a couple of boom lights at a yard (1 m) apart, at least with any degree of ease, the studio needs to be at least 16 ft (5 m) wide, and preferably 20 ft (6 m) wide. It also needs to be high: a minimum ceiling height of around 10 ft (3 m) and preferably 13 ft (4 m) or more.

Feathering

Very often, though far from invariably, movie stills were not made with spotlights focused tightly and shining directly onto the subject. Rather, the spot was defocused somewhat, and the edge of the light beam was used, a technique known as 'feathering.'

Lighting Ratios

The lighting ratio is most simply defined as the ratio of the key light to the fill light. In other words, if there is a key light coming from camera left and a fill coming from the direction of the camera, the left-hand side of the subject will be more brightly lit than the right-hand side. If there is three times as much light falling on the left-hand side as on the right-hand side, the lighting ratio is 3:1. A wide variety of lighting ratios will be found in this book. The important thing to realize is that the lighting ratio refers to the total amount of light falling on the subject, so unless the key and fill are diametrically opposed, it is not possible to measure lighting ratios by turning the lights on alternately. Some photographers actually measure lighting ratios using either a flat-receptor incident light meter or by taking a reading off a gray card, while others judge the ratios by eye.

Brightness Ranges

The brightness range is quite different from the lighting ratio. It is the ratio of the brightest part of the subject to the darkest, but it is complicated by the fact that it may be measured at four stages. There is

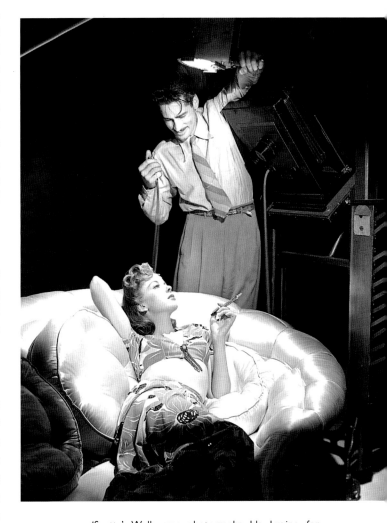

'Scotty' Welbourne photographs Ida Lupino for Warner Bros in 1940. The most interesting things about this picture are the massive camera stand – no flimsy tripod here – and the slots for a dozen 8 x10 in. film holders that can be seen on the side of the stand, on the right of the picture: holding 24 sheets of film.

the brightness range of the original subject; the brightness range of the image on the ground glass; the brightness range recorded on the negative; and the brightness range of the print.

Hollywood portraits were quite often lit with a fairly broad lighting ratio, possibly giving a subject brightness range of 64:1 or more. But the uncoated lenses of the day would reduce a 64:1 brightness ratio by 1 or 2 stops, to 32:1 or even 16:1. Fairly short exposures would then lose a fair amount of shadow detail, leaving the shadows inky and 'empty.' Finally, the papers of the era before World War II often had brightness ranges that were very short by modern standards: the brightest highlight on the print was commonly around 40 times brighter than the darkest shadow. Today, at least 100x would be regarded as normal, partly as a result of brighter whites, but principally as a result of blacker blacks.

Tungsten versus Flash

Continuous or tungsten lighting will make it much easier to light in the classic, formulaic styles: 'butterfly,' also known as Paramount, (pages 92–93) and 'loop' (page 59). Focusing spots give an effect, a hardness to the light, that is impossible to replicate with conventional electronic flash, even snooted – though Fresnel flashes are available or can be cobbled together. Although it is possible to do a surprising amount with a single light, access to one focusing spot and one broader, softer light makes it possible to do a great deal more. The only style of lighting for which electronic flash is clearly superior is very soft lighting, when an umbrella or (much better) a soft box beats anything you can do with tungsten and is, in addition, more comfortable for the subject.

Shadows

In most varieties of portraiture, double or 'crossed' shadows are anathema: any student on a craft-oriented photographic course would fail the basic examinations if he or she turned in portraits with such a defect.

In Hollywood portraiture, this convention does not seem to apply, perhaps because crossed shadows don't normally matter in a movie: when the subject is moving, we expect the shadows to move, while in a still portrait, we expect a more 'painterly' and natural use of light. When you start looking for crossed shadows while you are watching movies, they are so common and so blatant that you can quite lose track of the storyline.

In the course of researching this book, we rejected numerous portraits in which the multiple shadows were just too obtrusive, though if you want to see a picture with lots of conflicting shadows, turn to page 35. We believe that the Hollywood photographers of the 1930s and 1940s could get away with more than we can today, partly because some of them were very good indeed, and partly because the stars they photographed were often so iconic that even bad

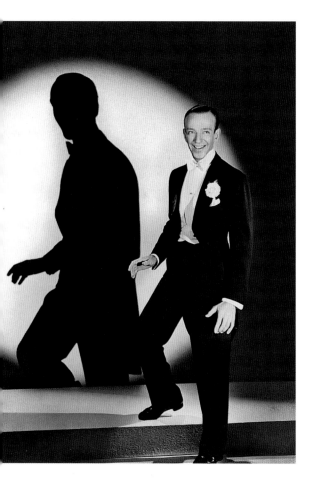

Things are not always what they seem. When you look at this picture closely, you realize that the 'shadow' does not quite match the pose and that there are no corresponding shadows between Fred Astaire's right foot and the somewhat truncated 'shadow,' which appears to be a cardboard cutout. (Laszlo Willinger, 1940.)

LIGHTING BASICS

There is a basic vocabulary of lighting that remains in use to this day. First, there are the uses to which the lights are put: key, fill, effects, and background. Then there are the ways in which lights are modified, to make them harder or softer, or to shade off parts of the subject. In color there is also the question of 'gels' (pronounced 'jells,' from 'gelatine,' although they are now typically made from acetate). These are used to modify the color of the lights and they do not affect us here.

Key lights cast the principal shadow. Where there are conflicting shadows – as there often are in Hollywood portraits – the light that determines the shadows on the face is taken as the key.

Fill lights, as their name suggests, fill in the shadows so that they are more or less 'open' and not empty or inky.

Kickers, also known now as **effects** or **FX lights,** are used to light specific areas. The hair light is perhaps the most widely used effects light; others may be used for jewelry, for example, or to bring out details in a fur. The distinction between kickers and fill lights can sometimes be hard to make in Hollywood portraits.

Background lights, logically enough, light the background, although this may also be lit with 'spill' from other lights.

Any of the above lights may be modified in a number of ways. Some of the more common terms are listed here:

Barn doors are doors mounted on the front of a light. They are partially opened or closed to control the area lit by that lamp.

Egg crates are grids of slats, somewhat resembling an egg crate. They are used to make the light from a broad, soft source more directional. The modern 'honeycomb grid' for electronic flash uses exactly the same principle.

Snoots are conical or cylindrical tubes, mounted in front of the lamp, that are used to limit the area lit.

Flags or **French flags** are sheets of opaque material, used to shade or 'flag off' areas of the subject so that the light from a particular lamp does not fall full on them. They may also be used to shade the camera lens to prevent flare. The term 'gobo' is used instead of flags by some photographers.

Cutters are long, thin finger-shaped flags.

Cookies are flags with holes, typically used to project a dappled light on a background. Cookie is allegedly an abbreviation of 'cucaloris,' but equally 'cucaloris' may be a back-formation from cookie, from which holes appear to have been cut with a cookie cutter. Then there are those who say that the word is 'cucalorum' or 'cocalorum.' Some photographers call cookies 'gobos.'

Scrims are diffusers made of wire mesh or fabric to soften a light.

Fingers are long, thin scrims, like a scrim version of a cutter.

Dots are small round scrims, about 3 in. (7.5 cm) in diameter. Quite often two are used together to create shaped shadows, particularly to shade the shoulder nearer the camera.

Targets are bigger dots, about 8 in. (20 cm) in diameter. They are also known as 'silks'.

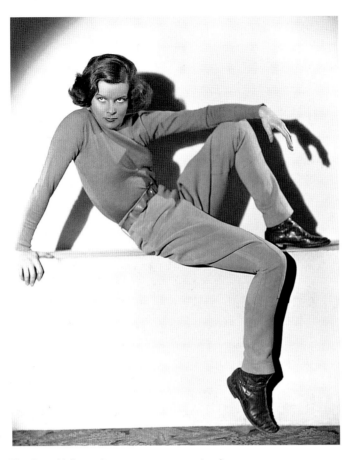

The best Hollywood portraits are portraits first, Hollywood second. This picture of Katharine Hepburn was taken by Robert Coburn in 1933 for *Christopher Strong*. It is a superbly executed 8 x 10 in. shot but as far from the repetitive, formulaic pictures taken by some of his contemporaries as you could get.

The nose shadow in this portrait of Norma Shearer could be happier, but the interesting part is the blurring of the moving beaded dress during an exposure that probably ran to ½ second. Once the camera is on a tripod, the biggest danger to sharpness is the subject moving closer or further away between focus and exposure. (Photographer not credited, 1927.)

photographs looked good. In other words, it is not good enough today to equal the Hollywood masters: we must surpass them, at least in this respect.

RE-CREATING THE HOLLYWOOD LOOK

There are certain ground rules that can give any portrait a Hollywood flavor. Poses are an obvious example: even if you don't need easy-to-hold poses for the same reasons that the old Hollywood portraitists did, they are still a part of the Hollywood look. So are cigarettes, though as noted on page 10, the subject must be able to hold them convincingly. The same is true of guns for the tough-guy look. Make-up, hair, clothes, and jewelry should either be timeless or as close as possible to 1930s and 1940s originals.

Keep backgrounds simple but don't use modern, bland, seamless paper and mottled fabric backgrounds. Use pools of light, or dramatic shadows, or cookies, to add interest. Remember, though, that in Hollywood, things are not always what they seem: the 'shadow' in the image on page 14 must be a cardboard cutout, not a real shadow at all.

Don't worry about shadow detail – Hollywood portraits rarely had any – so keep exposures short, but do not skimp on development. This is the exact opposite of most modern advice, which is to expose generously and curtail development.

After this, the easiest way to re-create the Hollywood look is to work as closely as possible to the way that the original Hollywood photographers worked: use an 8 x 10 in. camera and long, fast, uncoated lenses. This need not be as expensive as you might think. Fewer and fewer professionals today use 8 x 10 in. cameras, so old, second-hand monorails can often be found at the same sort of price as a decent new 35 mm compact or a mid-range digital camera. Old lenses are harder to find, but when you do find them, they are rarely expensive. Then you need a shutter, but once again, venerable front-of-lens shutters do not cost much: a lens and shutter together need cost no more than a good, new teleconverter for 35 mm. Once you have the camera, lens, and shutter, all you need is an 8 x 10 in. film holder, some film, somewhere dark to load and process the film; and a big, solid tripod.

If you reject this approach, you will have to resort to fudging and faking. To begin with, you need to light more softly, to compensate for the lower flare of modern, coated lenses: lighting ratios should rarely exceed 8:1 (3 stops), even for dramatic character portraits, and 4:1 (2 stops) or less may be advisable for soft, romantic images.

Lenses should be longer than 'standard' but not enormously so: even 90 mm may be longer than you need on 35 mm, and if you can find something like the old 58 mm f/1.4 manual-focus Nikkor you may be amazed at how suitable it is. On 645 and 6 x 6 cm go for 100 or 110 mm if you can; on 6 x 7 cm something like 127 mm or at most 150 mm; and on 4 x 5 in. no more than 210 mm. Soft focus is tricky, even on 6 x 7 cm; on anything smaller the effect may be pleasing, but it won't look like Hollywood.

To keep depth of field shallow, the smaller the format, the wider the aperture at which you should work. On 35 mm a 58 mm f/1.4 could with advantage be used at full aperture.

Use the biggest format you can and, preferably, a slow film as well. On the other hand, Ilford's XP2 Super (ISO 400) is a good bet, even in 35 mm, as it offers very fine grain with a softness of texture that is reminiscent of a larger format. With this film, do not curtail exposure too much or grain will be bigger than at the nominal speed. For the classic Hollywood look you only want an 8 x 10 in. enlargement, which is, after all, the same size as a contact print.

Tilting the camera sideways, to add 'dynamism,' is a classic Hollywood trick, although this can be interesting if you are working with a medium-format camera that has a waist-level finder.

A very weak blue filter – the palest blue you can buy – will give a color response that is closer to the films of the 1930s, while a stronger blue filter will give a color response closer to 1920s ortho emulsions, though results without are also likely to be acceptable.

After this, it's a matter of practice and more practice – and of looking closely at pictures and thinking hard. You can apply the same techniques of analysis when you see a picture you particularly admire. Look at the highlights and (particularly) at the shadows: these should enable you to work out the direction of the light and whether it was hard or soft. Once you have formed the habit of analyzing pictures, and once you have had a little success with blatantly formulaic 1940s lighting, you will be well placed to produce Hollywood-style portraits that might even – dare we say it – be better than many in this book.

Finally, a note on the drawings that accompany the descriptions: these lighting plots are intended as an aid to help you visualize roughly where the lights are and should not be taken as definitive. Without the accompanying text, they are of limited use only, and the ultimate authority should always be your own analysis and experimentation, based on the photographs themselves.

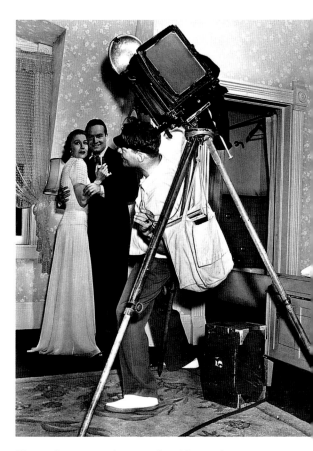

This is almost certainly a complete fake, as there is inadequate extension on the camera for a shot at this distance unless a wide-angle lens was in use. On the other hand, the tilting of the camera is entirely believable. (Shirley Ross, Bob Hope, and photographer William Walling, for *Thanks for the Memory*, 1938.)

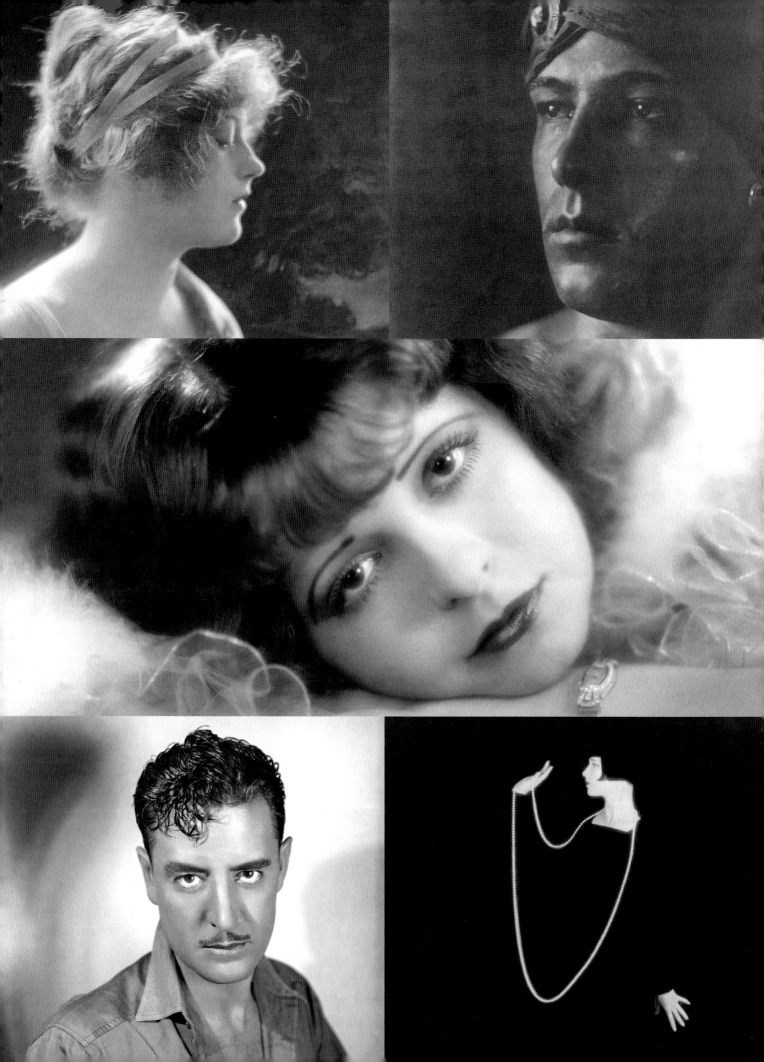

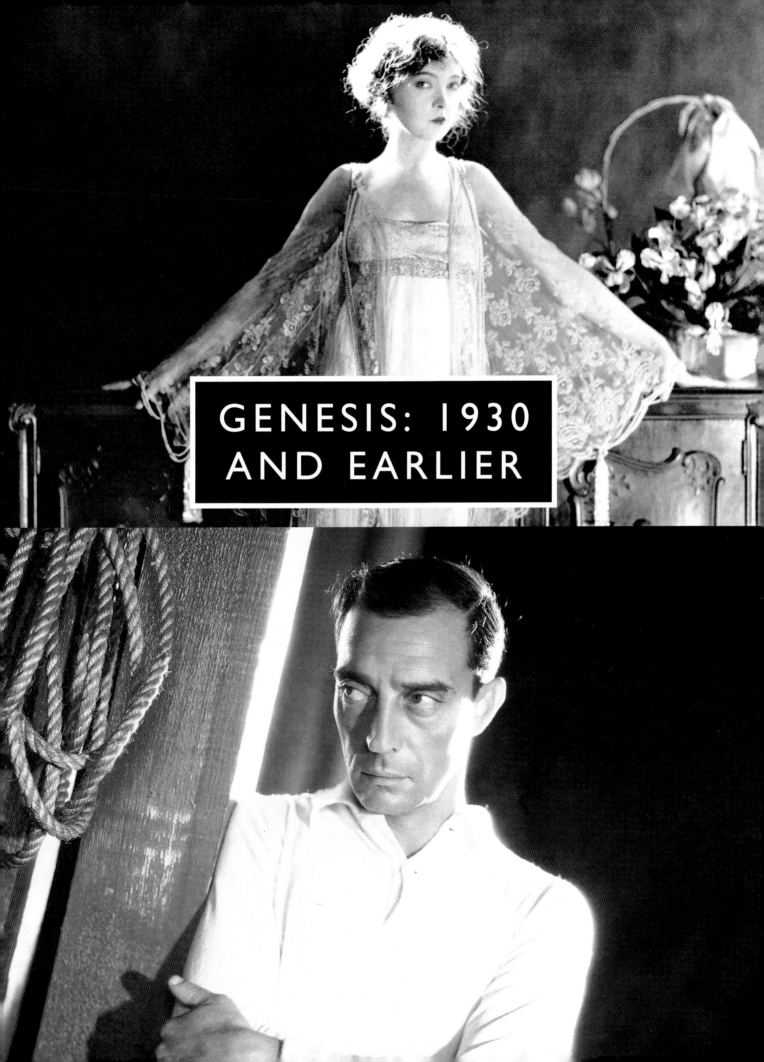

GENESIS: 1930
AND EARLIER

GENESIS
1930 AND EARLIER

Many movie-star portraits from before the end of the 1920s owe a clear debt to traditional, formal studio portraits, which had changed surprisingly little since the 1870s. Others demonstrate the new Hollywood ethos: a freewheeling mixture of entrepreneurship, opportunism, and a willingness to try one's hand at anything. The best of the new Hollywood photographers revealed an unexpected genius; others were merely in the right place at the right time.

Happily for the publicists, the rise of the movies coincided with the rise of the photographically illustrated periodical. Illustrated journals were nothing new, but in the nineteenth century they had used engravings and even woodcuts. Now, photomechanical

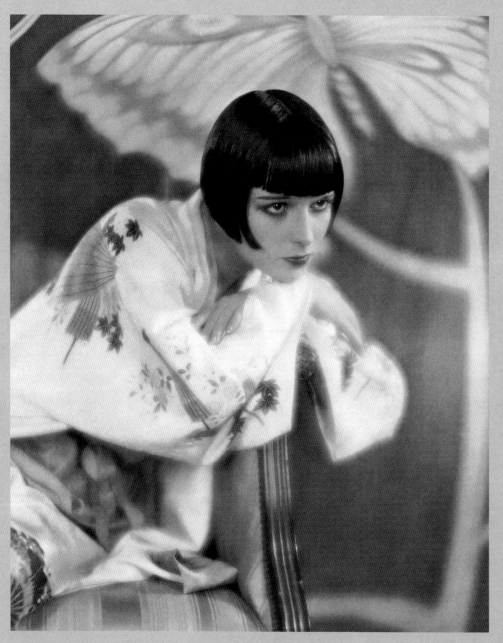

This portrait of Louise Brooks, by E. R. Richee in 1926, could have come straight from the pages of Steiglitz's *Camera Work*, which ceased publication almost a decade earlier. The generous soft focus, the Art Deco-cum-Japanese theme, the limited (but exquisitely controlled) tonal range, all bear witness to influences such as Edward Steichen and Baron de Meyer.

reproduction meant that there were unparalleled opportunities for promoting these new 'stars' via their photographic portraits.

Many early star portraits were shot in New York, rather than Hollywood, because the stars had already learned to demand the best of everything, and the best photographers (or at least the best known, or at the very least the most expensive) were in New York. In those pre-airline days, stars and executives, and even those most despised among the dream-merchants, the writers, shuttled back and forth across the country by rail.

The more traditional photographers still used daylight, with glass roofs and walls and complex systems of blinds, but 'half-watt' (tungsten) electric lighting was becoming more popular. In Hollywood carbon arcs were more widely used, and 'Klieg eye' was a recognized occupational hazard: it was, in effect, sunburn of the retina, caused by the very high ultra-violet content of carbon arcs, of which Klieg was a major manufacturer.

Ortho films (non-red-sensitive) were still widely used, leading to rosy complexions. They were developed in pyro-soda and similar formulations, so grain was very coarse indeed. Photoelectric exposure meters were still in the future: although patents went back to 1880, the first meter to achieve wide sales, the Rhamstine Electrophot, would not appear until 1931, and the first Weston meter, the Universal 617, not until 1932.

The smallest format in common use was half plate (4¾ x 6½ in./12.1 x 16.5 cm), though whole plate (6½ x 8½ in./16.5 x 21.6 cm) and 8 x 10 in. were generally regarded as preferable. Still bigger sizes – sometimes much bigger – were also used. Enlargements were quite properly regarded with deep suspicion, and contact printing was the accepted route to good quality.

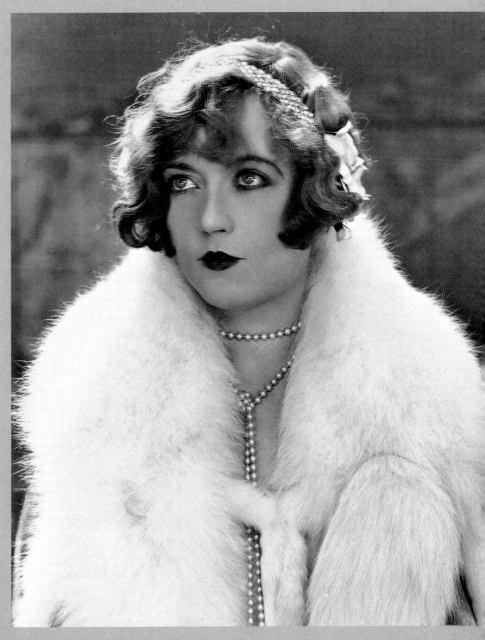

To judge from the shape and number of highlights in the eyes, this 1927 portrait of Marion Davies by C. S. Bull was taken in a daylight studio where the quantity and direction of the light could be controlled by numerous shutters in a room that was half way to a glass house. Examination of the hair and highlights shows that Ms Davies may have moved quite significantly during an exposure that could have run to a second or more.

Of course, the 1930s were already foreshadowed in some of the work of the late 1920s. Indeed, one of the fascinations of the history of photography is the way in which, in the same decade, one photographer might prefigure the work of half a century later, while another recalls the work of half a century earlier. This is a phenomenon that we shall see again and again throughout this book.

NINETY-FIVE PERCENT PUBLICITY

Marion Davies 1897–1961

Photographer: Campbell Studios, New York, 1919, attributed tentatively to Arnold Genthe

Degree of difficulty: Moderate (4 lights)

Marion Douras described herself by saying, 'With me, it was five percent talent and ninety-five percent publicity.' Such self-deprecation supports Charlie Chaplin's verdict that she was a natural comedian and could have been a star in her own right, instead of the product of William Randolph Hearst's expensive and often misguided hype.

This portrait is very much in the romantic studio tradition, with painted backdrop; something similar could have been taken with ease at any time in the previous couple of decades, and with only slightly more difficulty in a daylight studio of the 1880s. The most difficult thing to reproduce today is the soft focus effect, which would have been achieved with a purpose-built soft focus lens. If the soft focus was adjustable, it must have been cranked over to the limit. The bigger the format, the easier it is to achieve controllable soft focus effects – especially when you want to go this far over the top.

Four lights appear to have been used in total, all of them big and soft. The key is to camera right, above and slightly behind Ms Davies. This provides the striking rim light on the nose, lips, chin, and left side, the highlight on the eyelid, and (probably) the light on the front of the hair, although there might just have been a fifth (hair) light somewhat above and behind her and on the subject–camera axis. The fill is to camera left, and there is clearly a strong 'kicker' or effects light almost directly behind her. The remaining light, probably on the floor, lights the painted backdrop.

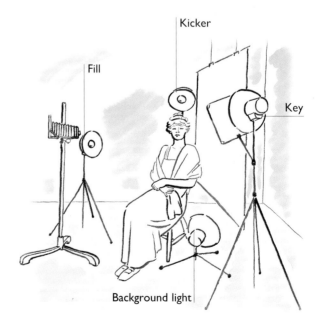

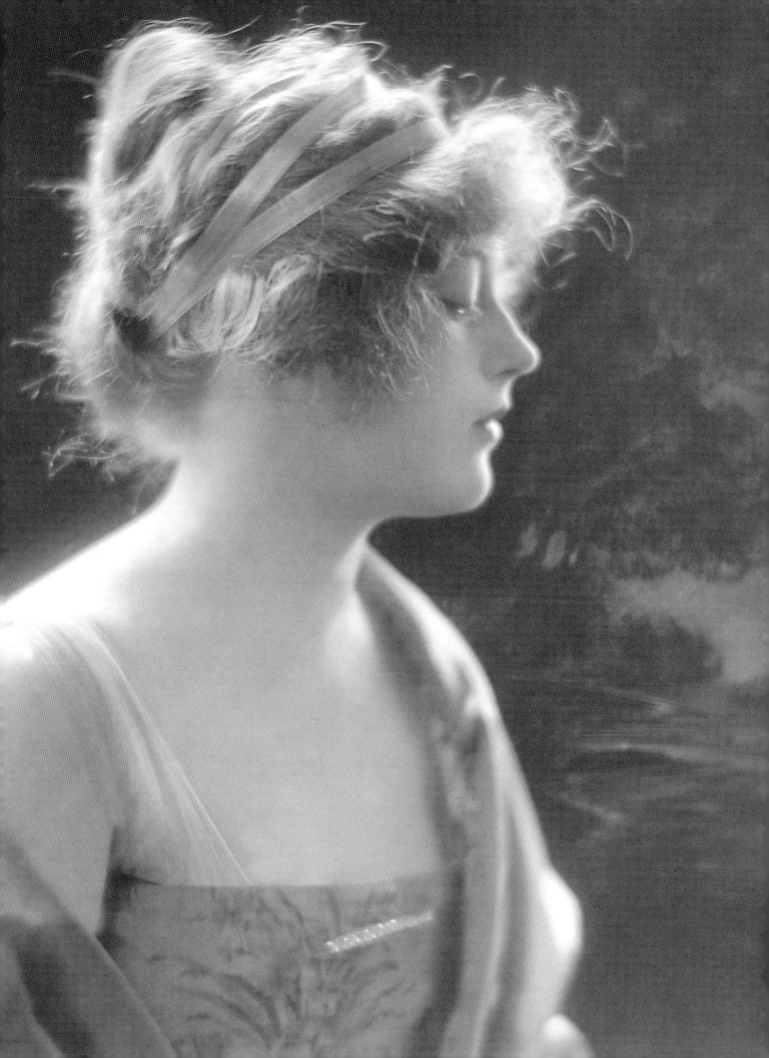

BIRTH OF A STAR

Lillian Gish 1893–1993
Photographer: James Abbé, 1920
Degree of difficulty: Moderate (3 lights)

Lillian Gish was a child performer who became one of the very first movie stars. She began in the days when actresses had to be young in order for their complexions to register pleasingly on film: her first part in a film was in 1912, when she was 16. By the time of *The Birth of a Nation* (1915) and *Intolerance* (1916), she was an experienced silent-movie actress; when this picture was taken, contrary to her almost childlike appearance, she was well into her twenties.

This picture is as much fashion plate as portrait, with very good detail in the dress, but the dramatic hair lighting differentiates it from traditional studio portraits. Insofar as the hair is to a large degree burned out, the hair light could be said to be overdone; but this is merely an illustration of how a good photographer can take what would normally be a fault and transform it into art. There is no doubt that the face draws the eye even more than is normally the case in a portrait and that the lighting is principally responsible for this.

As far as composition and pose go, it is not a particularly remark- able portrait, but note how one foot is in front of the other, adding to Ms Gish's ethereal appearance, and how the fingers rest lightly on the sideboard, so that the wrist is not awkwardly flattened.

There seem to be three lights. The key is a large, powerful light to camera right: the shadow of the leg of the sideboard is the clearest indi- cation of its direction, though it can also be seen in the catchlights in the eyes. There does not appear to be a fill; at most, there is perhaps a bounce. The other two lights are both hair lights, one left and one right.

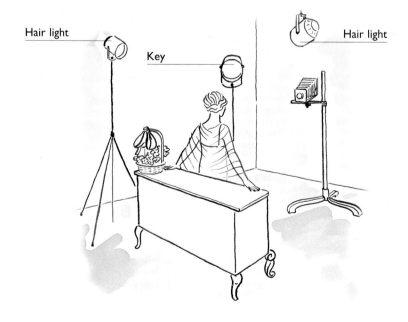

Hair light · Key · Hair light

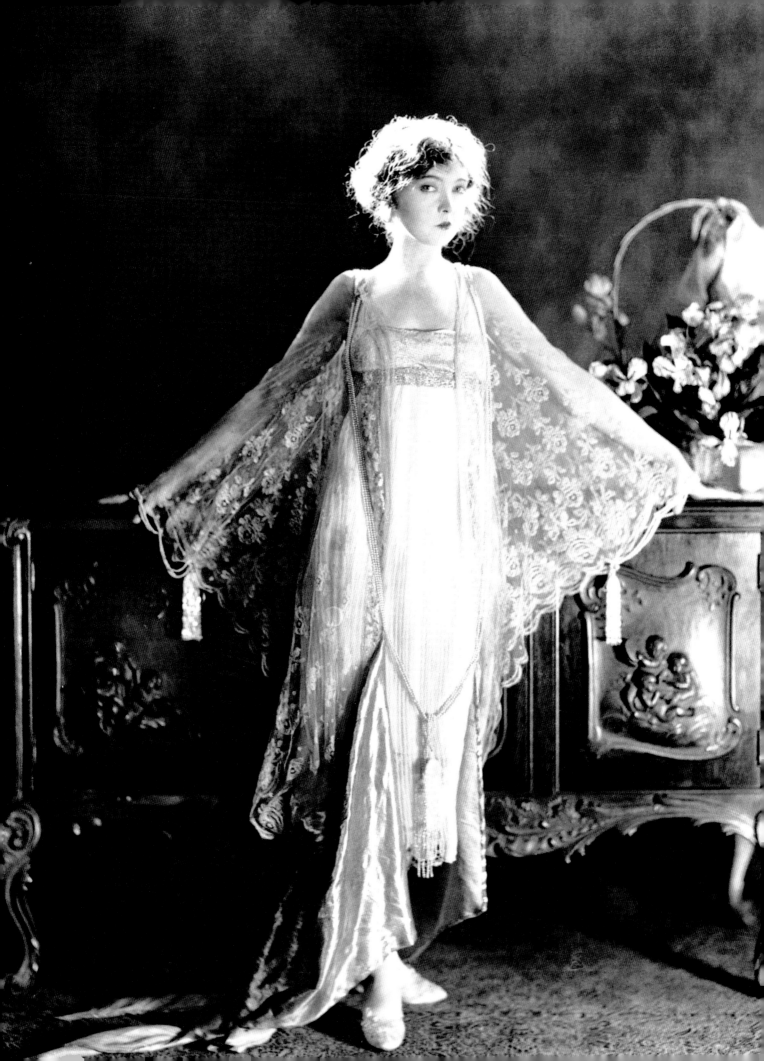

THE SHEIK

..

Rudolph Valentino 1895–1926
Photographer: Ashley-Shaw, 1922
Degree of difficulty: Fairly easy (2 lights)

Rodolfo Alfonso Rafaello Pietro Filiberto Guglielmi di Valentina d'Antonguolla's first film, made in 1914, bore the slightly risqué title of *My Official Wife*. In 1921, the year before this picture was taken, a total of seven movies starring Valentino were released, including *The Four Horsemen of the Apocalypse* (the film that is often credited with making him a 'superstar') and *The Sheik* (perhaps his best remembered film today, at least among non-aficionados).

This is a first-class 'large head' shot, with dramatic chiaroscuro on the face and masterful use of the highlights along the top of the shoulder. The earring is important for balance: cover it with your thumb, and the picture fades to a dull blur on the right. There is some retouching on his right cheek, though not on what appears to be a rather badly flawed complexion on his left cheek. The strong lighting from the other side minimizes this, though there is an unfortunate catchlight there.

Technically, the print leaves much to be desired. Contrast is low, and there is considerable evidence of indifferent processing and bronzing of the shadows. On the other hand, does this matter? This pose and lighting could readily be duplicated with low-cost tungsten lighting and a 35 mm camera; but would it have the same impact with a different subject and taken by a different photographer?

Valentino's skin appears to have been oiled or cold-creamed for this shot. The key is a fairly large light to camera left (his right) and slightly behind him; a flag was probably used to shade his right shoulder. A smaller, weak fill to camera right and slightly in front is evidenced by the highlights on the cheek and the earring. Catchlights from both can be seen in the eye.

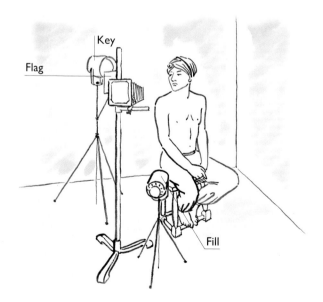

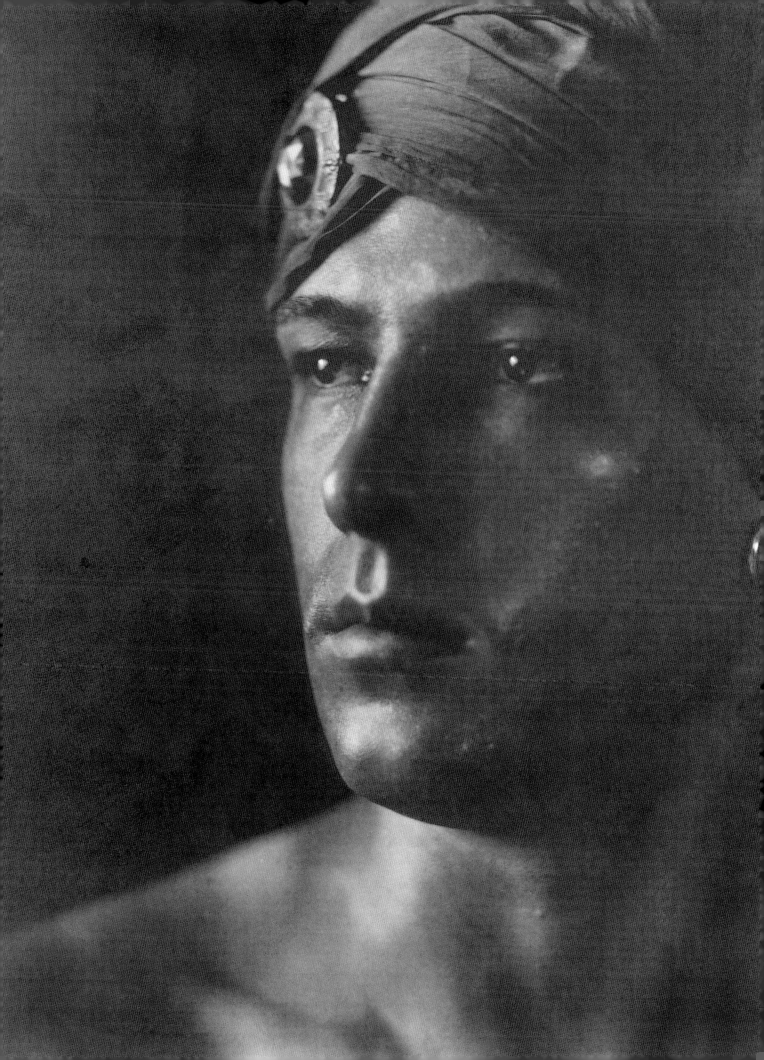

THE IT GIRL

Clara Bow 1905–65

Photographer: E. R. Richee, 1927
Degree of difficulty: Fairly easy (3 lights)

Clara Gordon Bow was the fantasy girl of the 1920s, the beautiful, seemingly demure flapper who thumbed her nose at convention and respectability – although, as she said herself: 'Being a sex symbol is a heavy load to carry, especially when one is tired, hurt, and bewildered.'

Some of this world-weariness is evident from the stare and the set of the mouth; an advantage of the pose, however, was that it could be held without discomfort and without movement, allowing plenty of time for accurate focusing, trying different degrees of diffusion, and then the usual sequence of close lens/insert film holder/pull slide/fire shutter/re-insert slide. Although there is a good deal of soft focus, the overall look of this portrait is much more of the later Golden Age of Hollywood portraiture, than of the early days.

When this was taken, she was at the height of her career, with around three dozen films to her credit. Releases for 1927 included *It*, *Children of Divorce*, *Rough House Rosie*, *Wings*, *Hula*, and *Get Your Man* – a punishing schedule by anyone's standards. She was still four years from the scandal that finished her career with Paramount; a scandal which, in addition to what might be called normal promiscuity, apparently included an orgy with an entire football team.

There seem to be three lights here. The large key is clearly to camera right and above – look at the nose shadow and the larger catchlight in the eyes – while a smaller fill to camera left and at about eye level is evidenced by the smaller catchlight and the illumination of the lower lip. The hair light is a little too 'hot' and matters are not helped by the somewhat flat-topped hairstyle.

This picture, also by E. R. Richee, looks more as if it was taken in the 1970s than the 1920s; two conflicting dates on the back of the print give 1925 and c. 1927. The catchlights in the eyes give away the principal lighting, a high left key and a low right fill of almost equal intensity; the background is lit separately.

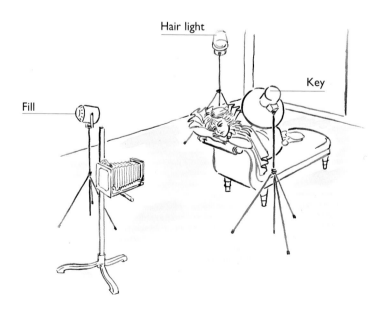

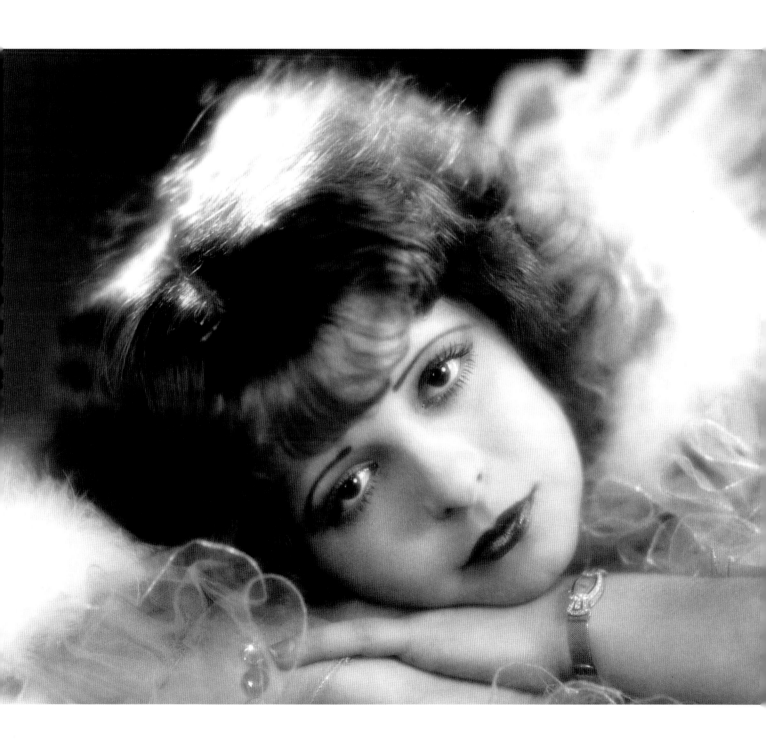

BEARDSLEY REVISITED

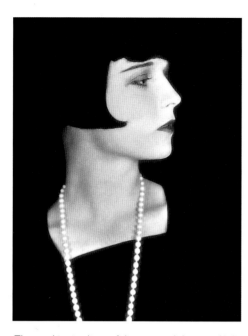

The graphic simplicity of the pose and the use of light and dark shapes almost without chiaroscuro are reminiscent of the pen-and-ink work of Aubrey Beardsley and is an excellent illustration of the way in which a photographer should be familiar with more areas of the arts than his or her own narrow specialization. Even so, the soft focus effect adds a uniquely photographic dimension.

Louise Brooks 1906–85
Photographer: E. R. Richee, 1928
Degree of difficulty: Fairly easy, if retouched (2 lights)

Mary Louise Brooks was around 19 when her first film, *The Street of Forgotten Men*, was released in 1925. By the time these pictures were taken, she was well established as a Hollywood leading lady, though aficionados maintain that her best films were made in Germany.

Technically, the most interesting thing about these pictures is that they rely on heavy, but simple, retouching for a great deal of their impact. Ms Brooks was probably wearing a black velvet dress and standing in front of a black velvet background; but even with the minimal exposure that was the norm in Hollywood portraits, there must have been some highlights that had to be obliterated in the final image.

Because the retouching was almost certainly done on the negative, it was not possible to 'blow out' the background with an airbrush, which would be the easiest way (bar digital photography) to duplicate the effect today, working on a print. On the original print, scratch lines are visible to the right of the long sweep of pearls in the larger picture, and bleach was presumably used (on a wet negative) to remove other unwanted details. Even the hair has been bleached into the background.

Both the large and smaller picture are lit substantially identically, with what might be called 'copy lighting': that is, two lights, approximately equidistant, approximately the same power, at 45 degrees to the camera/subject axis, and either side of the camera. The clearest evidence comes from the double shadows on the pearls against Ms Brooks's neck in the smaller picture. There are no awkward double nose shadows because the face is in profile.

'Copy light'

'Copy light'

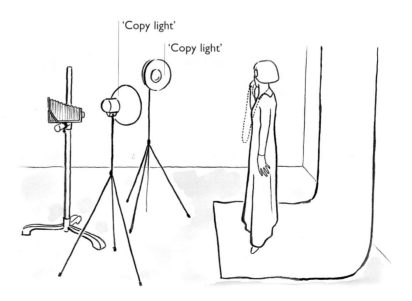

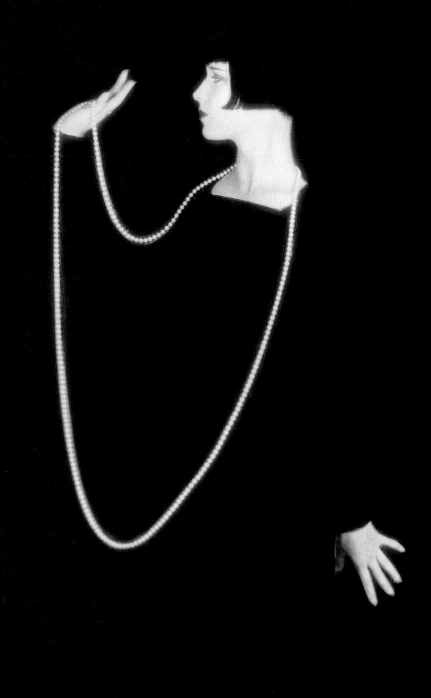

GEORGE HURRELL

George Hurrell (1904–92) was a perfect example of what can happen when genius and luck collide. Technically, his portraits can collapse if they are subjected to close analysis. Double shadows abound; highlights are frequently burned out, white from over-exposure; and it sometimes seems that he did not pay adequate attention to the sharpness of anything except his subject's eyes. But it doesn't matter. Both the immediate impact of his pictures and their longer-term staying power are enormous. Hurrell did not just photograph his subjects the way that they wanted to be seen: he photographed them the way we want to remember them. This was his genius.

As for luck, he was in the right place at the right time. At the age of 21, fresh from the Art Institute of Chicago, he was commissioned to photograph paintings at Laguna Beach, which was a favorite gathering-place for artists. He seems, however, to have had an extraordinary natural talent for portraiture. Through the usual route of a friend of a friend of a friend, he photographed Ramon Novarro in 1929. Norma Shearer saw the pictures. He photographed her. And in 1930 he was hired as chief portrait photographer by the head of Metro-Goldwyn-Mayer, Irving G. Thalberg, who just happened to be Shearer's husband.

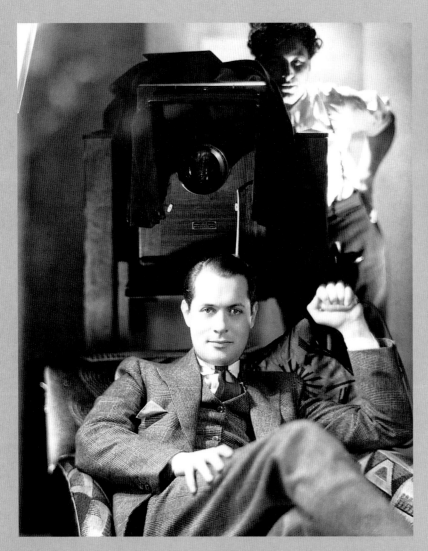

Above: This portrait of Ramon Novarro was one of Hurrell's earliest as a Hollywood photographer and may even be from the series that got him his job at MGM. It is very different in style from the picture of Veronica Lake (opposite).

Left: The self-portrait of Hurrell with Robert Montgomery dates from the end of the MGM years in 1932. It seems to have been shot in a mirror: the lens data engraved around the bezel are flopped. The camera looks like an 11 x 14 in., which would have been used with reducing backs: the lens is a Taylor, Taylor Hobson 18 in. (46 cm) f/5.6 Series VI, serial number 123489, presumably a Portronic variable soft focus lens.

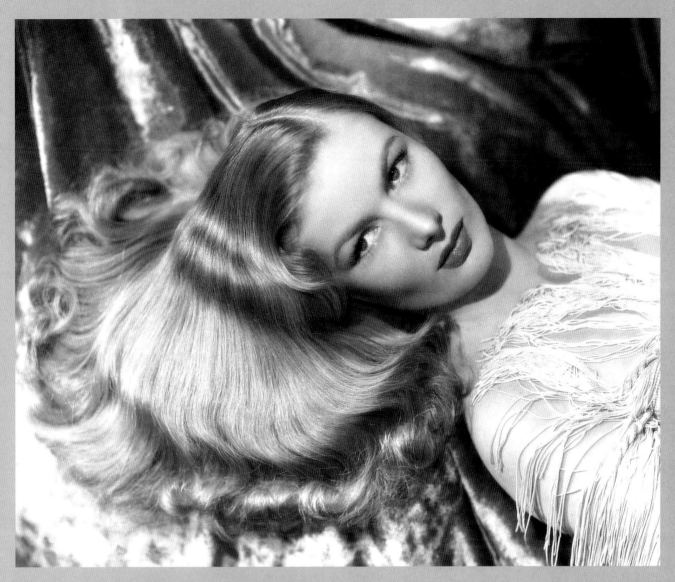

Imagine this picture without the rich, luxurious fabric under Veronica Lake, and without the shawl that simultaneously reveals and conceals. It would be much weaker, much plainer; and Hurrell did not willingly deal in either weakness or plainness.

The 1930s were Hurrell's golden decade, first with MGM, then on his own, and then with Warner Bros, with whom he stayed until about 1942, when he joined the USAAF to serve with the First Motion Picture Unit; the picture of Veronica Lake (above) dates from just before his war service. After the war, the new style of Hollywood portraiture – smaller cameras, less formal posing, and the arrival of color – was not to his liking, and he spent a lot of time in New York shooting fashion and advertisements, as well as running a TV production company in California. Late in the 1950s he returned full-time to movie stills, 'retiring' in 1976 but continuing to shoot star portraits and some fashion shots until shortly before his death.

From the point of view of cameras, materials, and darkroom technique, there is, in fact, not a great deal that one can learn from Hurrell: there was nothing particularly unusual about any of them. For that matter, as has been already noted, his pictures sometimes reveal technical shortcomings if they are analyzed too closely. By studying his pictures, however, one can learn – or at least appreciate – his instinctive awareness of the importance of lighting and the compositional skills of a true portraitist. Skills such as these are much rarer, and more valuable, than mere technical ability, and they illustrate well the old adage that 'Talent does what it can: genius does what it must.'

BULLETS AND BROWN EYES

John Gilbert 1895–1936

Photographer: Ruth Harriet Louise, 1929
Degree of difficulty: Challenging (probably 4 lights)

One of John Pringle's first films, from about ten released in the same year (1916), was *Bullets and Brown Eyes*. This sums up his career pretty well. He had the looks and the smouldering glance that were the *sine qua non* for a movie star of the period, but it seems that the talkies did him no favors when it became possible to hear his voice.

This picture has considerable initial impact – not least from the directness of the stare and the big eyes – but it does not stand up to prolonged analysis. Ruth Harriet Louise seems to have used rather more lights than were needed, and not to have used them particularly well. The result is a riot of conflicting shadows and highlights: so much so that the usual definition of 'key,' as 'the light that determines the shadows, at least on the face', is somewhat hard pressed.

There is one big light over the camera that is one contender for the key. It provides the highlights on the forehead and nose, and the shadows under the lips. Another light, to camera left, creates the nose shadow to camera right, the diagonal shadow under the chin, and probably explains the shadow on the background to camera right; this could also be called a key. A third light, a rather over-strength fill to camera right, creates the shadows on the right shirt sleeve (camera left) and beside the nose. There is probably a fourth light on the hair, though the highlights might be explained by the light over the camera. We confess ourselves stumped by the shadows in the upper left of the picture, unless the background is translucent and lit from behind.

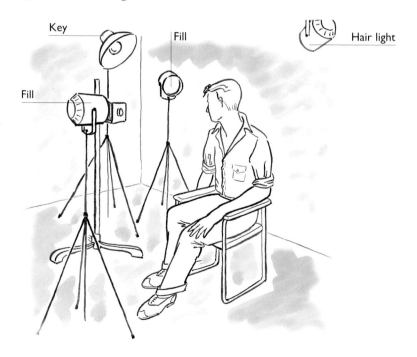

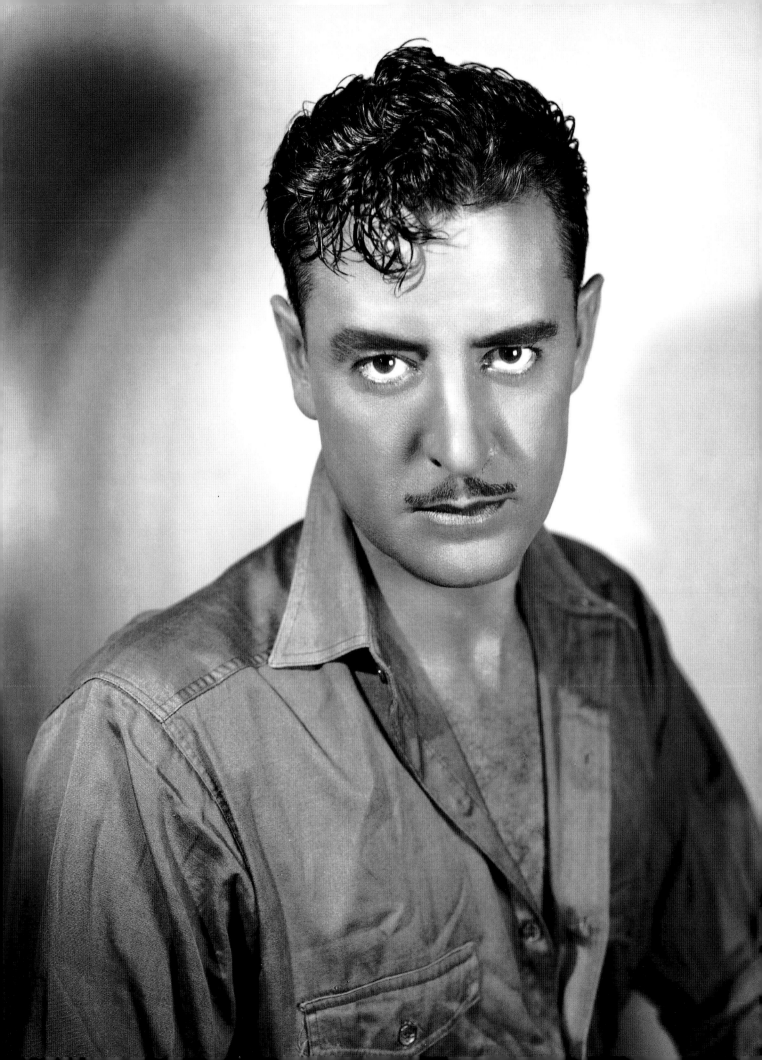

DEADPAN

Buster Keaton 1895–1966

Photographer: George Hurrell, 1930
Degree of difficulty: Fairly hard (4 lights)

Joseph Francis Keaton's film career began in about 1917, in two-reelers with Fatty Arbuckle. It is perhaps for his own silent comedies of the 1920s that he is best remembered, most especially *The General* (1927), though his career continued right up until his death in 1966: in that year he appeared in *A Funny Thing Happened on the Way to the Forum*, *The Scribe*, and *Sergeant Deadhead*.

The pose – leaning against the sloping timbers – echoes the genius that Mr Keaton himself had for creating uncertainty and confusion in his movies. Are the beams upright and is he leaning over, or vice versa? From the hang of the ropes, it looks as if it is a combination of sloping timbers, the subject leaning sideways, and the camera tilted.

There is still a fair amount of soft focus here, but it is less extreme than it was in the 1920s. Everything has been sacrificed to the skin tones. The highlights are 'blown,' and (in the usual Hollywood style) the shadows are blocked up. As so often with Hurrell's photographs, however, what we would see as faults in the work of a lesser master are transmuted into brilliance – literally, in the case of the shirt.

The minimum number of lights required to re-create this effect is probably four. The key is clearly from camera right, slightly in front of the subject. A fill, just to the left of the camera, is the second light. The third is a backlight at about 45 degrees to the subject–camera axis, to camera right again. There is another backlight to camera left, creating the highlights on the right side of Mr Keaton's face.

With the right subject, it is amazing how little you need to show. Here, Mr Keaton's trademark hat and even more trademark deadpan eyes are lit by a single lamp just above the camera: the effect is akin to on-camera flash. The big lights in the background are probably lit with two or more spots. If they were on, they would burn out completely.

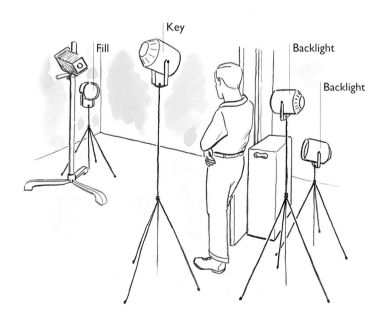

Fill

Key

Backlight

Backlight

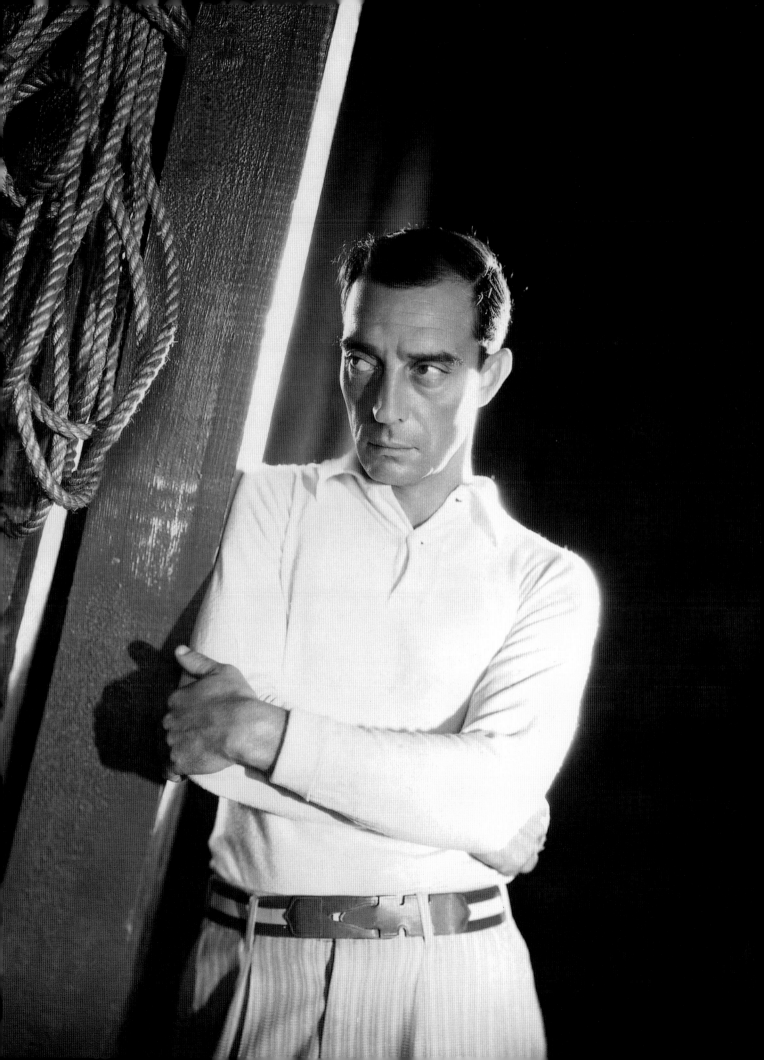

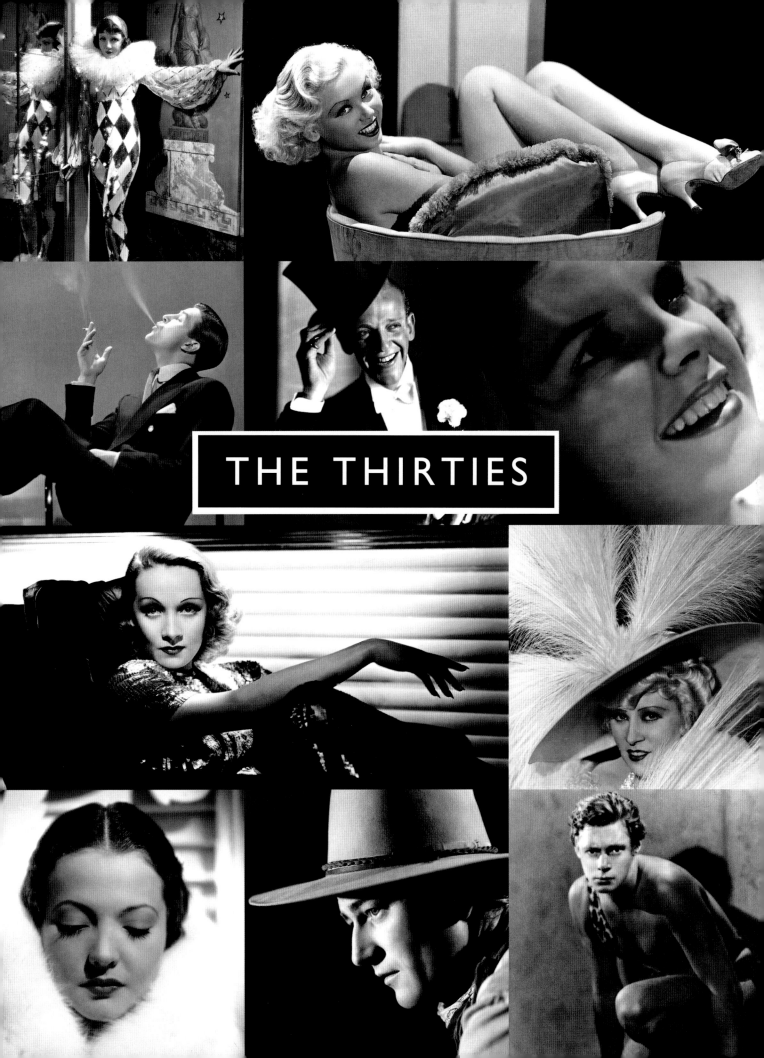

THE THIRTIES

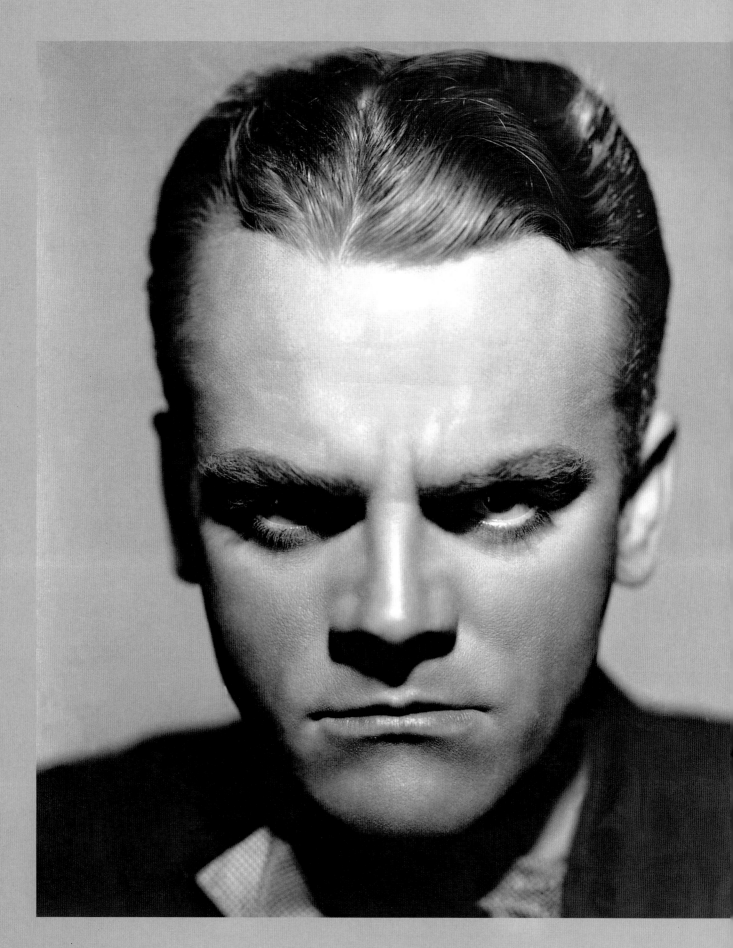

THE THIRTIES

Whether you choose the 1930s or the 1940s as the Golden Age of Hollywood portraiture is a matter of personal taste. Devotees of the 1930s decry the 1940s as a period of decline, in which lighting was formulaic and the stars grew less interesting as their more riotous behavior was curtailed both by public opinion and by a war economy. Devotees of the 1940s agree that the lighting could be formulaic, but counter, quite simply, with 'What a formula!'

By the 1930s the importance of New York had declined considerably: only a few money men remained there, although most of the better writers tended to earn their money in Hollywood and spend it in New York. After the late 1920s the big studios increasingly maintained their own staff photographers.

Although Leicas were in use in Hollywood by 1932, the vast majority of publicity pictures were now shot on 8 x 10 in. and contact-printed. Ansco was probably the most popular camera marque, followed by Kodak, and 8 x 10 in. sheet film was shot with a profligacy more reminiscent of 35 mm than of large format. With fewer and fewer exceptions, typically when shooting older female stars who needed all the help they could get, soft focus become subtler and subtler, or was abandoned altogether, though the actual lenses used were still nineteenth- or early twentieth-century designs.

Eastman Super-Sensitive Panchromatic Film, known to photographers as SS Pan, was introduced in about 1931 and soon displaced ortho film in the majority of Hollywood studios, as its enhanced red sensitivity meant that it did not render red lips as dark or complexions as rosy. Super-XX, with still better red sensitization, replaced SS Pan in the late 1930s, but it was still rated one-third stop slower to tungsten light than to daylight: as far as comparisons are possible, about ISO 80 and 100 respectively. With all of these types of film, halation – the

There is a great deal of light, very artfully deployed, in this picture of Virginia Mayo, which illustrates, literally as well as figuratively, the sheer richness of the best 1930s Hollywood photography. It is worth spending a few minutes trying to work out just how it was lit: in our opinion, with four or five lights.

tendency for a halo to form around light sources and highlights – was much more marked than with modern films. Although carbon arcs remained in use when high intensities were needed, or for point sources, they were less used by this time. Giant filament lamps were increasingly popular, not only because of the reduction of 'Klieg eye' but also because they were easier to turn on and off and did not make the buzzing or fizzing noise of carbon arcs, which could be an embarrassment when shooting synchronized sound.

Many photographers in the 1930s were scornful of exposure meters, maintaining that 'real' photographers did not need them, so technical quality remained variable. By now, retouchers were embedded in the whole system, and the skill with which they could remodel complexions is impressive to this day, though if you have access to original prints (and still more, to original negatives) some of their less subtle handiwork can also be clearly seen.

This is an illustration of the truth that there are no fixed rules, especially in Hollywood. In a normal portait, one would take care to reduce the impact of that mighty brow, but this threatening image (by 'Scotty' Welbourne, 1938) is totally in keeping with James Cagney's roles.

I WANT TO BE LET ALONE

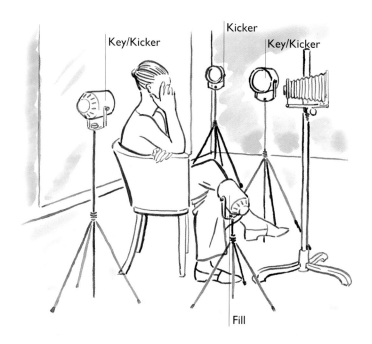

The lighting in this picture, taken in 1931 for *Inspiration*, is simple enough: a key from high on camera right, as evidenced by the nose shadow, and a fill from camera left, still fairly high, as shown by the catchlights and the lip shadow.

Greta Garbo 1905–90
Photographer: C. S. Bull, 1931
Degree of difficulty: Fairly easy (4 lights)

Greta Gustafson grew so weary of the attribution 'I want to be alone' that she actually said: 'I never said, I want to be alone. I only said I want to be let alone.' Her first movies dated from the silent era, though she hated to be reminded of it, and she suddenly retired in 1941, with the explanation: 'I had made enough faces.' Her own utterances were often those of a woman with her feet very firmly on the ground; the Garbo legend seems to have grown *malgré elle*.

The utter timelessness of the larger picture is fascinating, given how dated the smaller picture seems, as is the fact that both pictures were taken by the same photographer, in the same year. The greatest difference is between sharp focus and soft focus, but there are many other, smaller differences: the severe, timeless hairstyle of the big picture; the harder, more modern lighting; and the difference between a pretty girl looking demurely at the camera and a beautiful woman lost in her own thoughts.

The distinctions between key, fill, and kicker are somewhat blurred here. The strong light from camera right is definitely a kicker – an effect light-cum-hair light – but there are two candidates for the key, the strong light from camera left and the weaker one from camera right. The former throws the dominant shadows on the face, which is one definition of a key, while the latter gives the highlights and shadows on the nose, normally taken as being defined by the key. There is also a weak fill to camera left: look at the highlights on the hand.

Key/Kicker

Kicker

Key/Kicker

Fill

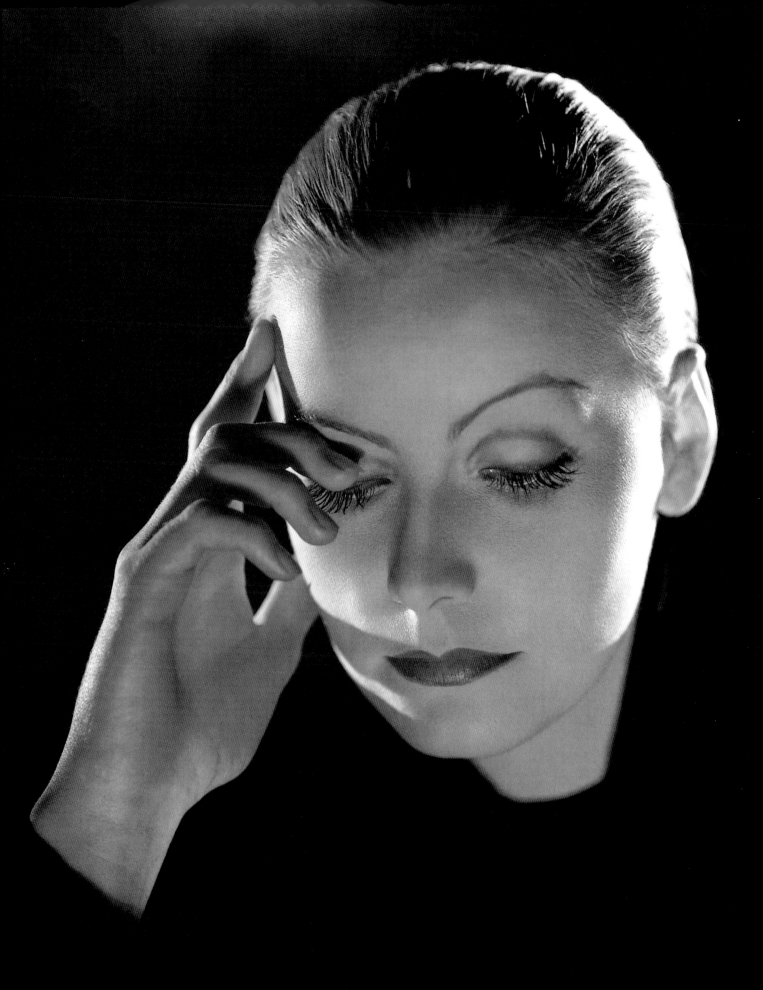

LORD GREYSTOKE

Johnny Weissmuller 1904–84

Photographer: Not credited, c. 1931
Degree of difficulty: Moderate to hard (3 lights)

Peter John Weissmuller was an Olympic athlete whose first guest appearance in a movie was in 1929. After 1932 he played Tarzan so often that his name became almost synonymous with the role: he appeared in around a dozen Tarzan films. The print is marked 'Tarzan test 1931,' and it might indeed be from the original series of test shots that landed him the job.

The soft focus and low key hark back to an earlier era. The pose is very well done and hard to shoot well: awkward folds and creases could all too easily have shown up without highly skilled lighting and masterful use of shadows, and with a less superb physical specimen this would be even harder to reproduce. There is also considerable risk of subject movement and loss of focus with such a pose.

Much of what seems to be chance in this shot is almost certainly well planned. The left hand may seem unnecessarily brightly lit, for example, but cover it with your fingers and the balance of the picture is destroyed. The highlight on the knife at his belt is also very useful.

There seem to be just three lights. The key is to camera left, at about 45 degrees to the camera–subject axis and quite high: look at the shadows of the eyes, nose, and lips, and on the left hand. This also explains the background shadow. A fill, to camera right, provides extra highlights and also fills the shadows, while the third light, to camera left and just behind the subject, is probably flagged off so that it does not light too much of his torso but still lights his head, right shoulder, and right arm.

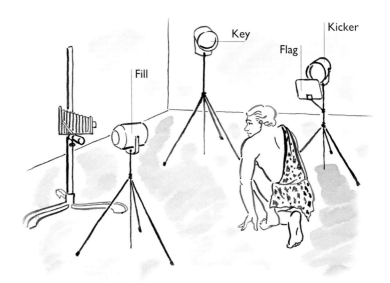

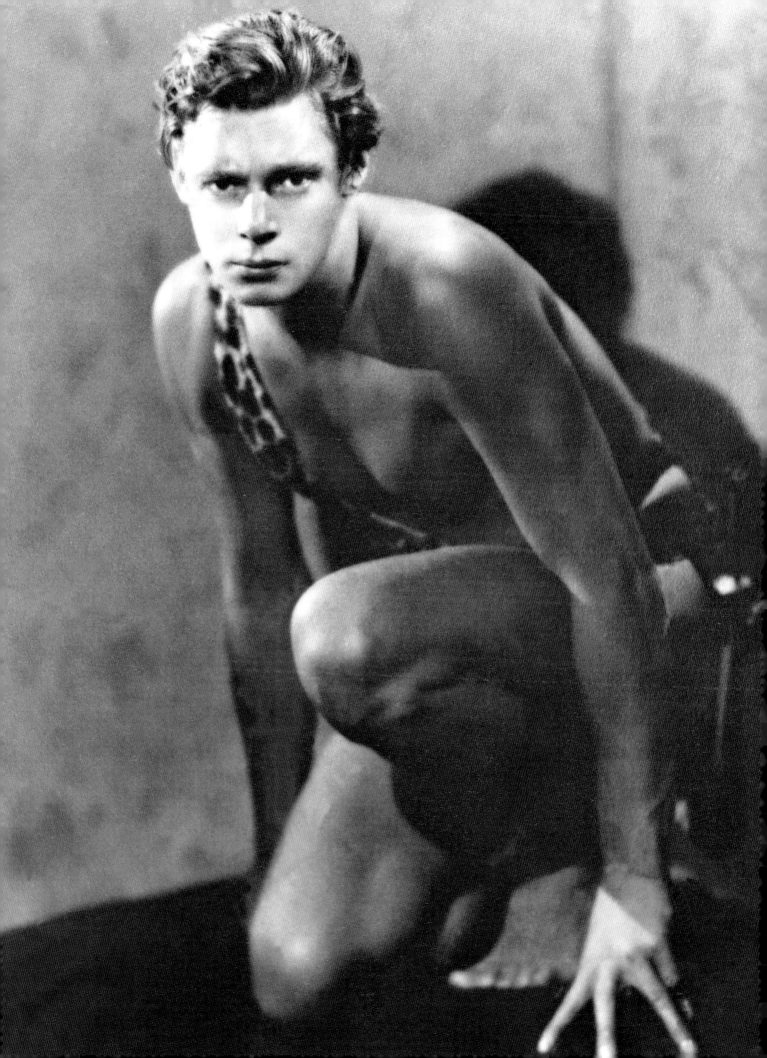

THE KING OF HOLLYWOOD

Clark Gable 1901–60

Photographer: George Hurrell, 1931
Degree of difficulty: Quite challenging (3 lights)

William Clark Gable made no fewer than 12 movies for release in 1931, and at that time George Hurrell was in the middle of his first stint as a full-time studio stills photographer with Metro-Goldwyn-Mayer.

This picture is somewhat different from Hurrell's better-known work. It was probably inspired by a real situation, which was then painstakingly re-created, including the careful choice of 'casual' clothing. Compositionally, generous use of diagonal picture elements adds dynamism to a superficially static pose.

It would be next to impossible to re-create this picture without access to a very large studio and the huge backlight, though a similar technique could be adopted for a portrait backlit by sun through a window. The more carefully it is analyzed, the easier it is to find fault: not just the conflicting shadows, but the awkwardly foreshortened left hand and the very 'hot' metal tag on the left shoelace. But none of it matters; in what pretends to be a grab shot, one can forgive a lot.

The key light is low and to camera left, though if you define a key as the one that determines the shadows, the fill that is set low and to camera right functions as a conflicting key. A flag casts a shadow on the right trouser leg and the wall to camera right, probably to stop the right shoe burning out and to avoid conflicting shadows to camera right. There may also be a flood as fill, set high above the camera, but if there is, it is fairly weak. The huge spot that dominates the overall scene has been very carefully positioned, and the wooden frame marked 'MGM SOUND STAGE 21' has been used as a flag: it would have been all too easy to have his hair burned out and his right ear transilluminated, so that it stood out and glowed. At least one additional light has been used to light the big lamps in the background.

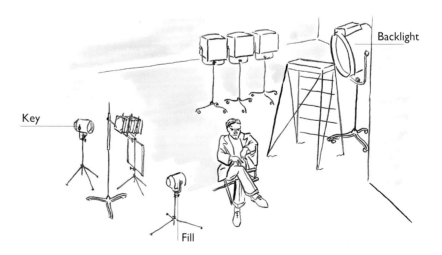

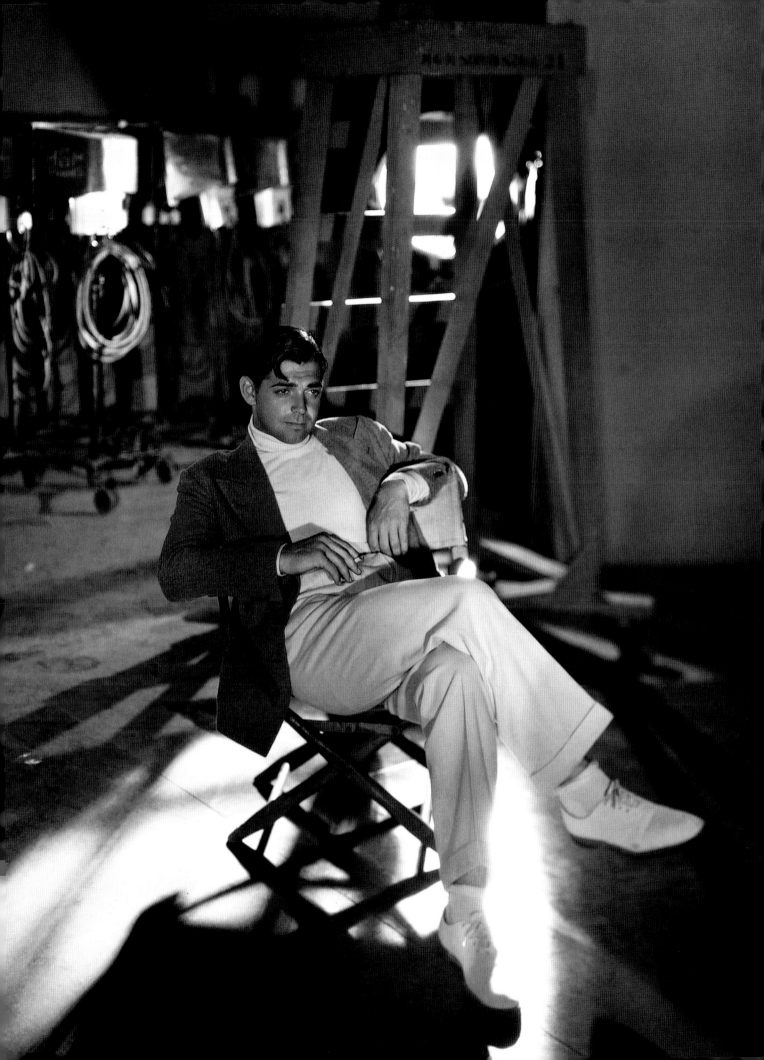

NOT THE GIRL NEXT DOOR

Joan Crawford 1904–77

Photographer: George Hurrell, 1932
Degree of difficulty: Fairly easy (1 light)

Lucille Le Sueur's movie career began in 1925 with five films and continued for the best part of half a century, and before she changed her name to Joan Crawford she was also known for a while as Billie Cassin. She famously said: 'I never go out unless I look like Joan Crawford the movie star. If you want to see the girl next door, go next door.' Bette Davis said of her, equally famously: 'The best time I ever had with her was when I pushed her downstairs in *Baby Jane*.'

The sheer lushness of this portrait certainly does justice to her desire always to look like Joan Crawford, and it is also an illustration of Hurrell at his best. Admittedly, the eyelashes and – even more – their shadows verge on parody for modern taste, but they are not an essential part of the composition. By way of experiment, we shortened them to a more natural length in Adobe Photoshop, and it was still a great picture. The heavy eye make-up is, however, probably essential – though it would be fascinating to try to duplicate this portrait with a blonde and a much lighter hat and fur.

Minimal exposure is an essential part of this picture so that the hat and background disappear into shadows. For that matter, there is no texture in the back of the hand. Something else that is apparent is the sharpness of the image, which is very different from the old Hollywood softies.

A single light, high to camera right, and approximately 45 degrees to the camera–subject axis, is apparently all that was used to light this portrait. If there were any fill, it would show in the back of the hand, and neither the hair nor the fur shows any sign of backlighting.

Key

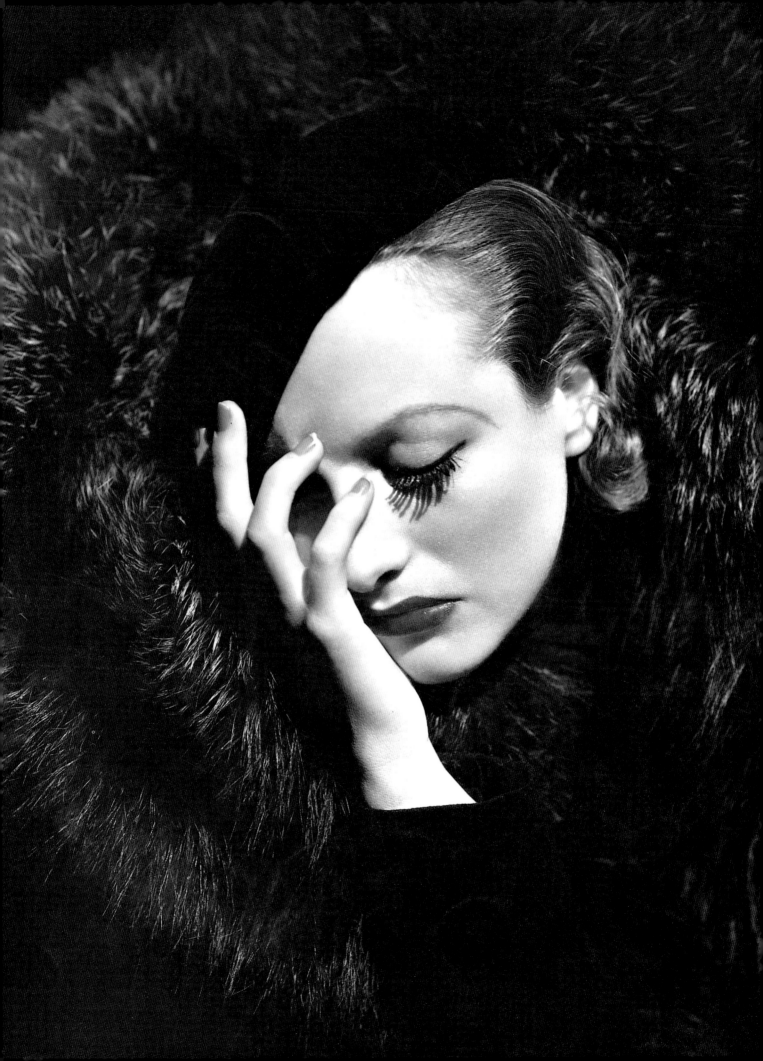

THE PLATINUM BLONDE

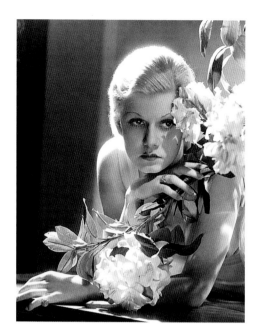

To anyone wishing to re-create this picture, we would recommend most strongly that they confine themselves to the cropped area above, as the extra space and extra light required to duplicate the whole set-up brings little benefit. Note (as ever) the stable pose, easily held: the flowers are also a useful tool for locating Ms Harlow's face on the subject–camera axis.

Jean Harlow 1911–37

Photographer: George Hurrell, 1932

Degree of difficulty: Not too difficult with cropping (4 lights)

Just 17 when her movie career began with *Moran of the Marines* in 1928, Harlean Carpenter's private life was as dramatic as the roles she played, earning the stinging observation that 'the T is silent, as in Harlow.'

This is a rather curious photograph in that there is a great deal of apparently wasted space. Most of the bottom half of the picture can be discarded, and the result is a stronger horizontal portrait. The right-hand side can, in turn, be cropped out, and arguably, the picture is strengthened yet again if you 'zoom in' to crop out the rather awkward light in the upper left-hand corner. One possible explanation is that Hurrell was instructed to leave space for text at the bottom of the image, not an uncommon requirement. Another flaw, the trimmed-off tips of the fingers, is most probably explained by this being a copy of an original, with some cropping having occurred in the copying.

The key is high and to camera right; look at the nose shadow and the shadow of the flowers on the face. There is a fill, pretty much alongside the camera: this provides the catchlights in the eyes. A third light illuminates the hair and shoulder; the curve of the shoulder against the background, lit only by spill, is particularly lovely. A fourth light, well to camera right and slightly behind the subject, lights the background and the vase and creates the rather awkward patch of light on Ms Harlow's left arm. This light could probably be omitted if one were creating a cropped shot (see left).

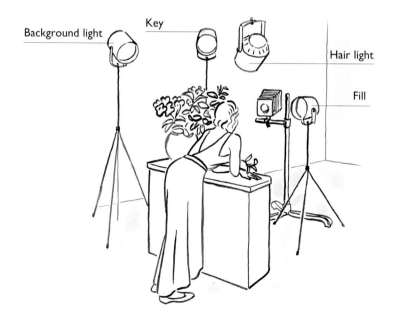

Background light Key Hair light Fill

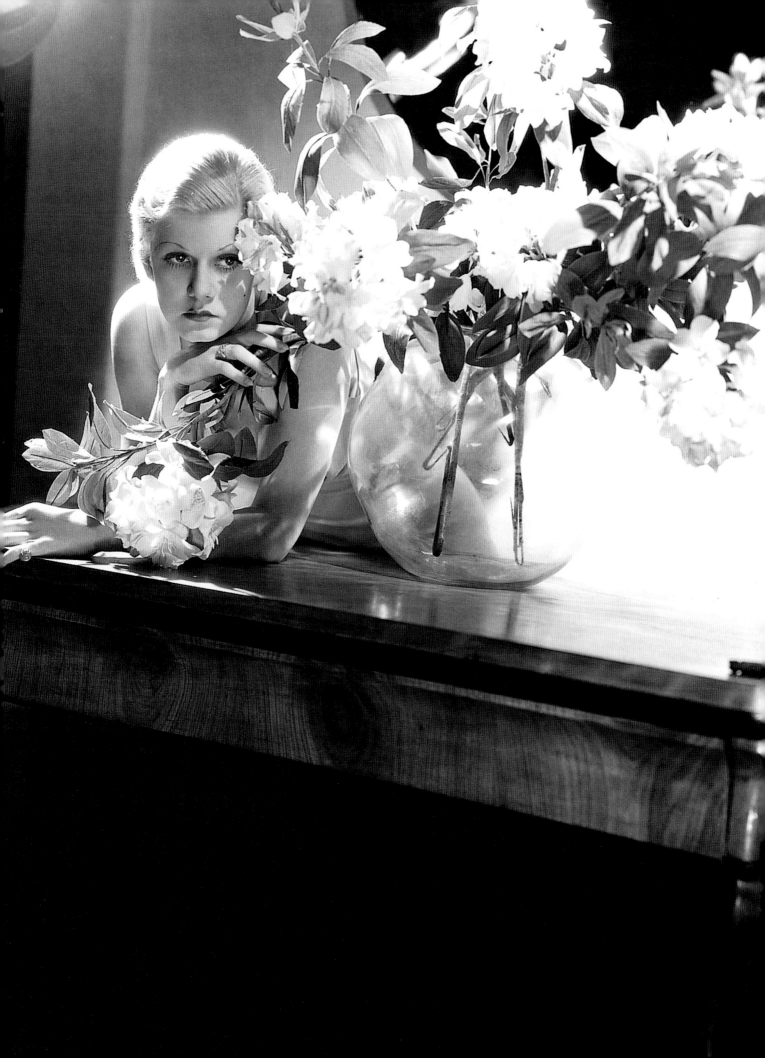

MRS THALBERG

Norma Shearer 1900–83

Photographer: George Hurrell, 1932
Degree of difficulty: Surprisingly easy (2 lights)

Edith Norma Shearer always photographed well, and there seems to have been a great deal more to her than meets the eye. Irving Thalberg, her husband, was head of MGM, and she was in large part responsible for George Hurrell's being taken on as a staff photographer for the studio. The target of at least her fair share of catty coments – 'A face unclouded by thought,' said Lillian Hellman – she nevertheless received an Academy Award for her role in *The Divorcee* (1929) and was nominated several more times. After Mr Thalberg died in 1936 she appeared in several more films, but effectively retired in the early 1940s.

The pose, as so often, is easy to hold, and the direct gaze makes for an intimate portrait.

There are only two lights here: it is an example of Hurrell at his simplest and best. The key is clear enough, with a flag to darken the lower part of the fur, and there is a fill to camera right, just alongside the camera, which also provides the catchlights in the eyes. In the original print, though probably not in reproduction, it is possible to see the shadow that this creates behind her head and to the left. A bounce throws some light onto the back – perhaps a little too much, but without some light there, she would look a very odd shape indeed.

This picture, also taken by Hurrell in 1932, would be a great deal harder to reproduce than the larger one. It is also disputable whether one would want to over-light the legs and dress as much as Hurrell did. The true key is arguably to camera right, just forward of Ms Shearer (look at the neck shadows), with a strong fill right alongside the camera, but the leg lighting overpowers everything. The main reason for including this picture is the ingenious use of a painted background, lit by a single light behind the sofa, to draw attention to the head.

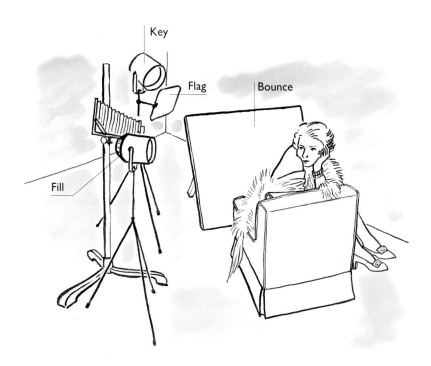

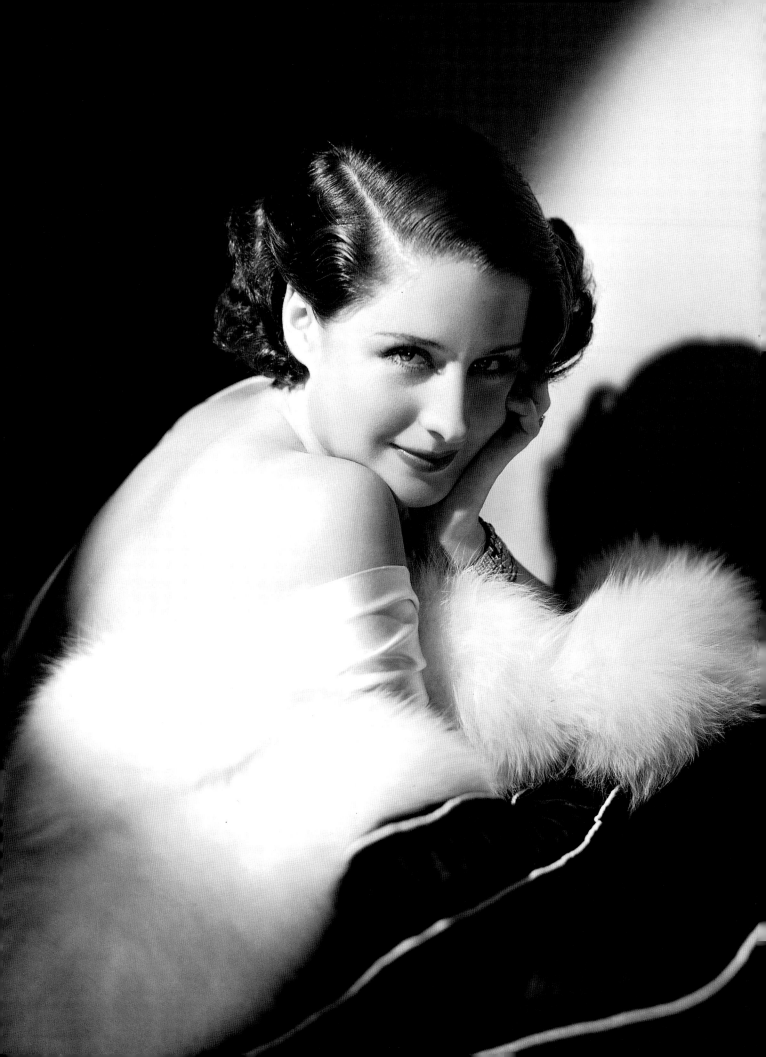

WORKING ON THE CHAIN GANG

Clive Brook 1887–1974

Photographer: Don English, c. 1932
Degree of difficulty: Extremely challenging

Clifford Brook is the oldest star to appear in this book. He was five years older than Mae West, nine years older than Lillian Gish, and the only one born in the 1880s. English by birth, he described Hollywood as a chain gang where the links of the chain are forged not with cruelties but with luxuries. His first movie, *A Debt of Honour*, was made in 1919, and he was at his peak in the late 1920s and early 1930s, though he continued to work into the 1940s and even appeared in *The List of Adrian Messenger* in 1963.

An interesting aside is that someone has chalked '1000W' on the light nearest the center of the picture, presumably because it had been fitted with a bulb of lower than usual wattage when a particular quality of light was required at a relatively low intensity.

The thing that is next to impossible to reproduce is, of course, the huge 'P' that genuinely does appear to be done with lights, although whether they are the same lights as appear in the picture is another matter. Then there are the lights that are used to light the lights themselves, principally from camera left but also from above. These have not been drawn.

As for the lighting on Mr Brook himself, the key is a big, soft light to camera left, set slightly above the subject's eye level. A second light from high and camera right acts as a fill, as evidenced by the smaller highlight in the eyes and the shadow on the left leg, while a third light, high and to camera right, backlights the whole of his left side (camera right); the shadows cast by this third light are very clear.

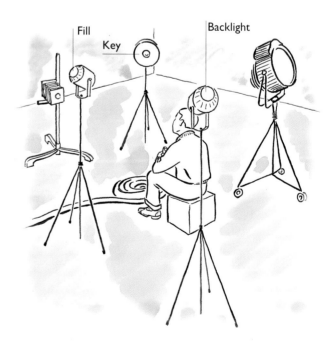

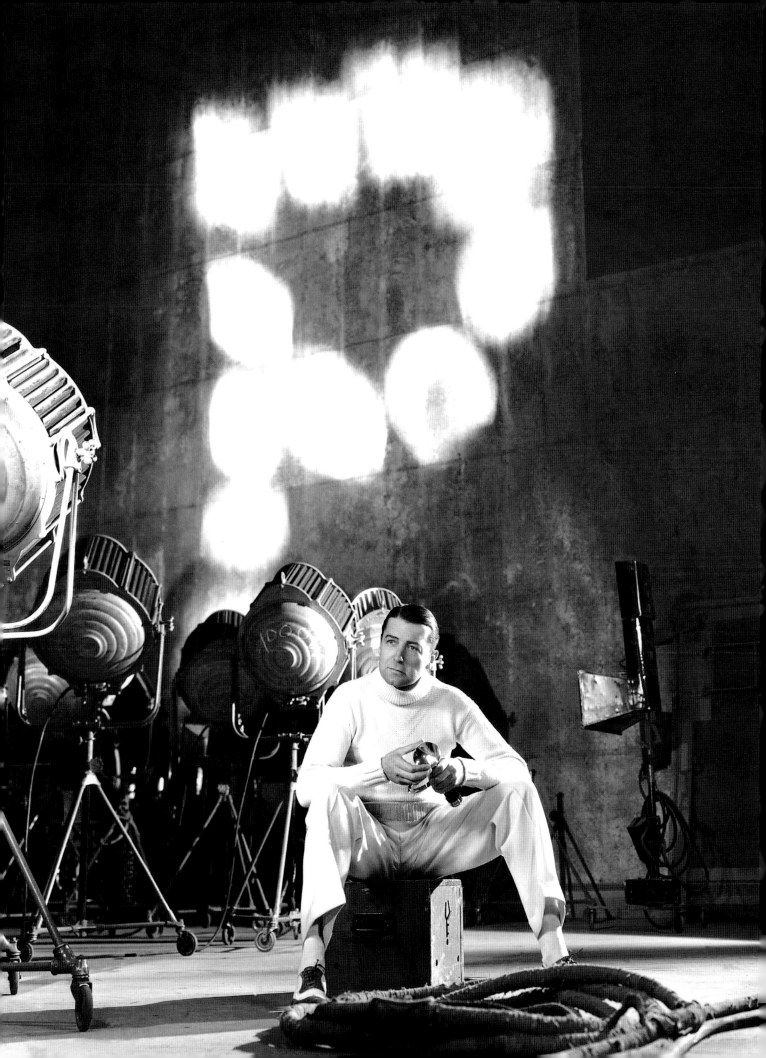

THE BEST WE HAVE

Spencer Tracy 1900–67
Photographer: Hal Phyfe, 1932
Degree of difficulty: Moderate to hard (3 lights)

Humphrey Bogart described Spencer Bonaventure Tracy as 'the best we have,' and Clark Gable was equally unequivocal: 'The guy's good. There's nobody in the business who can touch him.' And yet, the star himself was sometimes puzzled by his success. As he said to the press, 'Write anything you want about me. Make it up. Hell, I don't care.'

His film career began in 1930 with *Up the River*, and he was still able to attract an Academy Award nomination 37 years later with *Guess Who's Coming to Dinner*.

From the point of view of a photographer using an 8 x 10 in. camera, the pose is quite risky as there is a great deal of scope for movement toward or away from the camera. Also, the slightest up or down movement of the head would drastically affect the shadow from the peak of the cap. To guard against the latter problem, the photographer would be advised to watch the subject carefully, without using the viewfinder of an SLR, during the exposure. The way that the legs disappear into darkness is not something that might occur to a novice at portraiture, but it is extremely effective.

The key is the spot to camera right, slightly above Mr Tracy's eye-line, as evidenced by all the shadows, and there is a fill to camera left at something like 45 degrees to the subject–camera axis: look at the highlights in the eyes, the shadows on the fingers, and the secondary shadow behind his back. The curve of the back may be lit by spill from the key, or there may be a weak light, which is what we have drawn, or there may simply be a bounce.

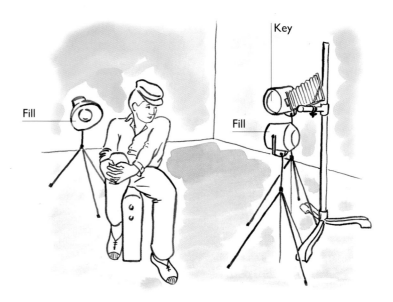

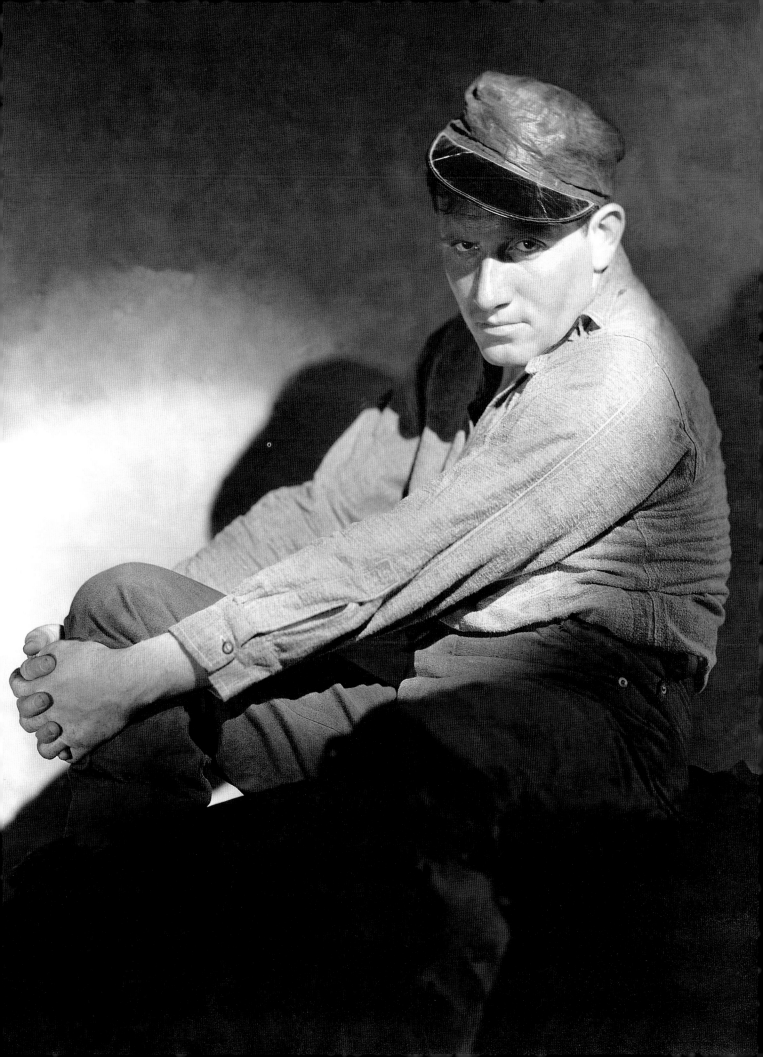

PURE AS THE DRIVEN SLUSH

Tallulah Bankhead 1903–68
Photographer: E. R. Richee, 1932
Degree of difficulty: Fairly easy (4 lights)

The contrast of light and dark by subject matter and viewpoint, rather than by lighting, is particularly noteworthy. E. R. Richee has made masterful use of the way that the hat blends into the collar and of the brilliant white of the scarf. At first sight, the black shadow on the right of the larger picture appears superfluous and detracts from the graphic simplicity of the shot, but, as the smaller image shows, removing it (in Adobe Photoshop) creates a very different picture without the air of mystery that informs the original photograph; it becomes much more of a record shot.

Tallulah Brockman Bankhead was a star of stage, screen, and real life, a personality larger than life; as *Halliwell's Who's Who in the Movies* so neatly puts it: 'Films never managed to contain her.' As well as describing herself as 'pure as the driven slush,' she produced such other gems as: 'Cocaine isn't addictive. I should know, I've been using it for years.'

There is a good deal of diffusion in this photograph, which brings to mind another Bankhead quote from later years: 'They used to photograph Shirley Temple through gauze. They should photograph me through linoleum.'

Although some photographers have an almost religious belief in eye contact and always ask their subject to look at the camera at the moment of exposure, many very satisfying portraits can be made with the subject looking slightly away, as here – and indeed as in many other pictures in this book. Looking too far to one side exposes too much of the white of the eye: merely looking past the camera, instead of off to one side, is almost always more successful.

This is a classic (and fairly early) example of what would later become known as 'loop' lighting, from the shape and position of the nose shadow. The key is slightly to the photographer's right, and rather above the subject's eye level, and there is a fill set rather lower and to camera left; the catchlights in the eye give the positions away. The background is separately lit, probably with two powerful lights.

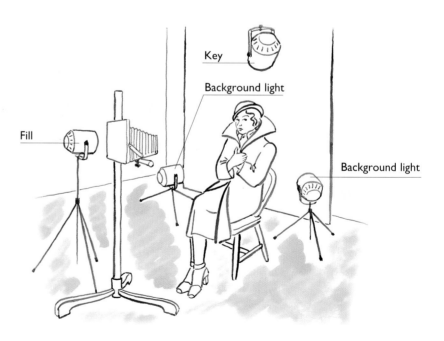

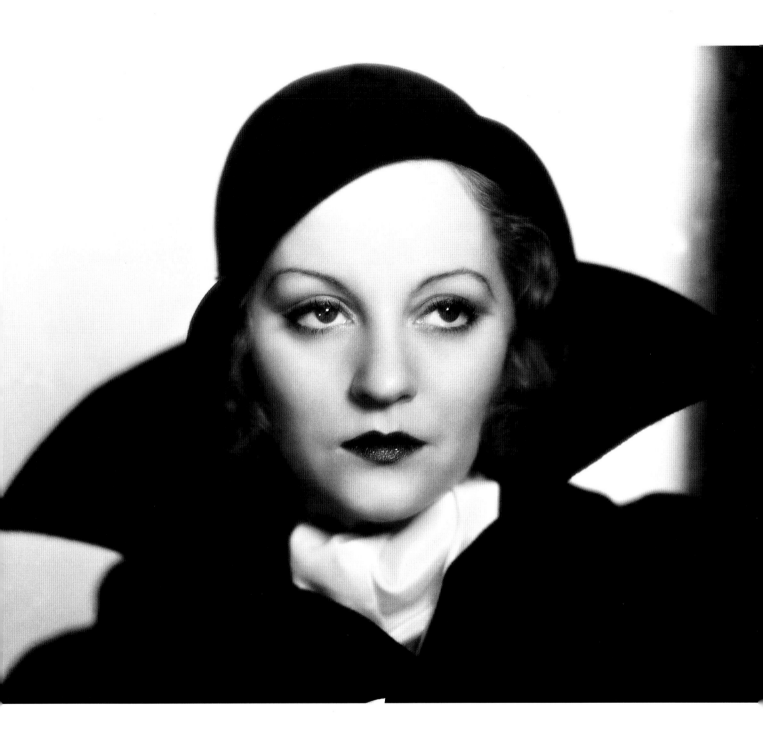

REGGIE THE FILM

Ray Milland 1907–86

Photographer: William Walling (?), no date
Degree of difficulty: Challenging (5 lights)

In Wales, where Reginald Truscott-Jones was born, there is a tradition of identifying people by their business. Reginald (or Ray) the Film appeared in his first two films in 1929, another 70 or so in the next two decades, and continuing right up to *The Masks of Death*, a 1984 TV movie. An Academy Award winner (for *The Lost Weekend* in 1945), he is surprisingly little remembered among non-aficionados today.

The insouciance of the pose recalls an earlier era, but the combination of art and artifice and the general sharpness of the image, are of the 1940s. The cigarette smoke must have required many takes, and continuous lighting explains the blur. It would be impossible to hold the feet still in this position for long, and this probably explains the unsharpness of the shoes. Mr Milland would have rested between focusing and the taking of the shot, and would have been unlikely to put his feet back in exactly the same place.

The negative was probably deteriorating along the lower edge when this print was made. Many Hollywood negatives have deteriorated badly already, and more will not survive long into the twenty-first century.

The key is almost directly above the camera–subject axis: look at the shadow of the ear. Then there are three lights between the camera and the subject, as evidenced by the reflections in the chrome: one big fill to camera right and two smaller fills, one high, one low, to camera left. The background is lit by a spot, which may or may not be the large right fill; from the evidence of the shadow on the background, we are inclined to suspect that it is another light.

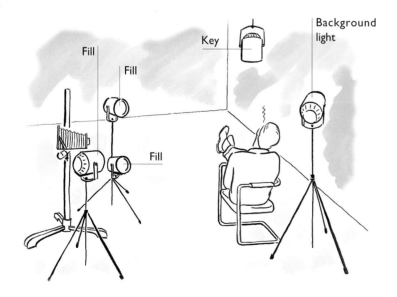

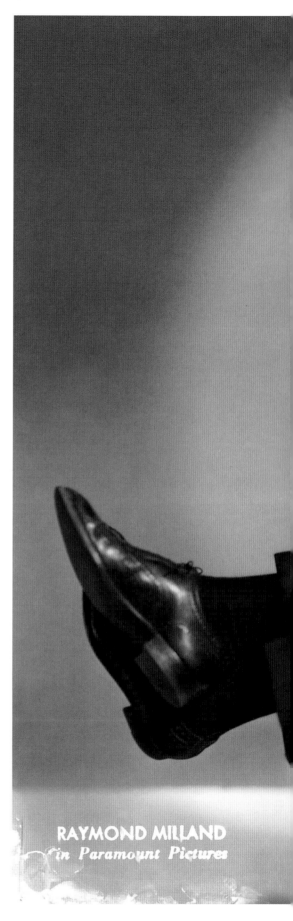

RAYMOND MILLAND
in Paramount Pictures

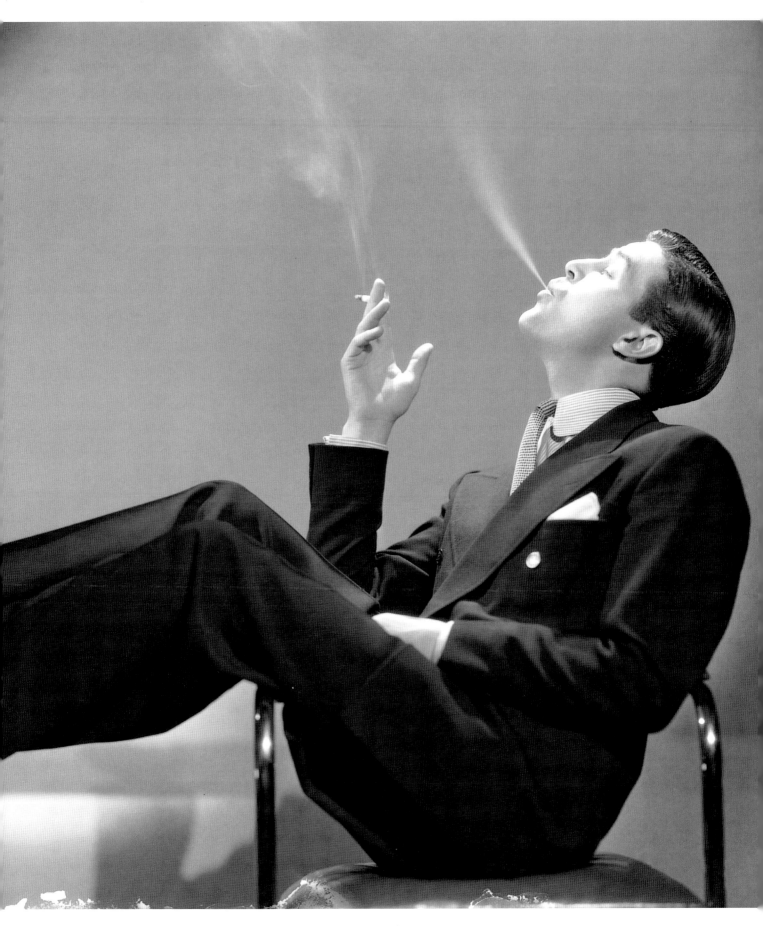

VIVE LA FRANCE

Claudette Colbert 1903–96
Photographer: Irving Lippman, 1933
Degree of difficulty: Challenging (2 lights)

Lily Claudette Chauchoin moved to New York from her native Paris at the age of 16 and began her acting career on the stage. Her first film, *For the Love of Mike*, was made in 1928, and by 1938 she was reputedly the highest paid actress in Hollywood.

Although there seem to be only two lights here, this (like any shot involving mirrors) is very hard indeed to do well. Even here, the flare from the harlequin costume is right on the edge of acceptability, though everything else is superbly done. In attempting to reproduce such a picture, it would be as well to keep the lighting ratio tight, as otherwise there is every risk of the ruff burning out completely.

Leaning against the wall makes it easier for Ms Colbert to hold the pose. Note how the fingers of the hands are delicately extended, and how she is carrying her weight on her right leg, which is concealed by her left. The latter allows an elegant flexing of the knee and pointing of the toes. Euterpe, of whom a *trompe l'oeil* statue appears in the background, is the muse of music and lyrics. Note the bright reflection of the dull star to the left of Euterpe.

The key is from camera right, well above the subject, but only slightly in front of her, as evidenced by the shadows on her face and hair. The fill is to camera left, much closer to the camera, and provides the highlights on the sequins, the catchlights in the eyes, and part of the shadow behind Ms Colbert against which the curve of her hip is so elegantly displayed. There appear to be no other lights.

EUTERPE

A WING AND A PRAYER

Toby Wing b. 1916

Photographer: William Walling Jr, 1933
Degree of difficulty: Fairly hard (4 lights)

Martha Virginia Wing – concerning whom our researches have proved lamentably deficient, save that this was a Paramount publicity shot – is presumably in some sort of chair, rather than an unusually luxurious dog-basket, and it may well be that she is somewhat more fully dressed than is immediately evident. We chose the picture simply because it is a classic piece of 'cheesecake,' a style that we have pretty much ignored elsewhere in the book.

In general, pin-up lighting tends to be generous, without much use of heavy chiaroscuro. This picture is evidently designed to appeal to connoisseurs of the leg; the direct stare, with eye contact, is also characteristic of pin-ups, although the actual look may be coy, or mock-surprised, or (as here) blatantly flirtatious.

As far as we can tell, there are four lights. The key is almost directly over the chair, as evidenced by the highlights and shadows on the face; this also functions as a backlight on the cushion fringe. A fill, almost at floor level and in front of the camera, lights the chair and the sole of the left shoe, as well as filling the shadows and providing shadows of its own on the left side of the cushion. A strong hair light to camera left lights her hair, and there seems to be one more light to camera right, which explains the second shadow on her left ankle and the shadow of her right knee on the background.

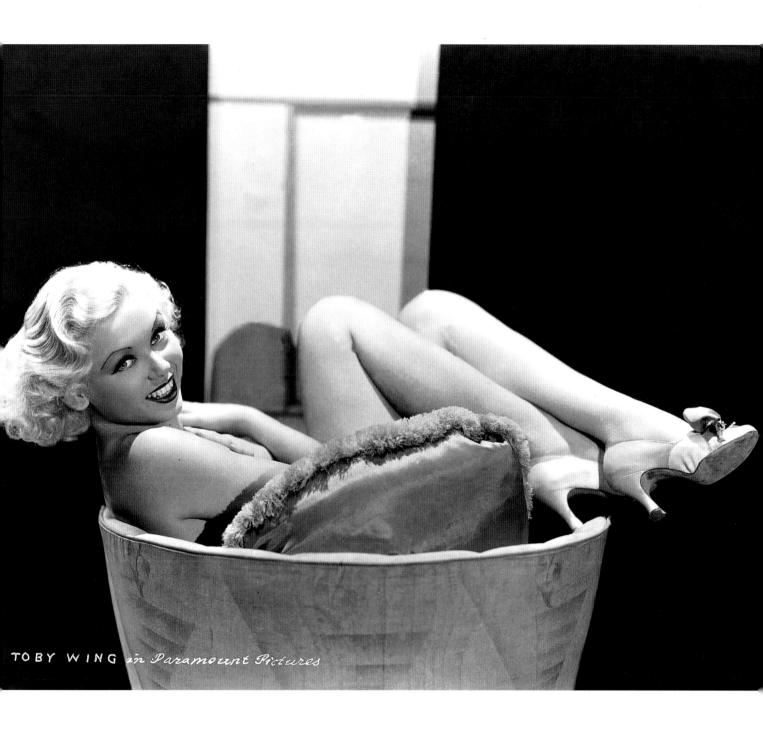

TOBY WING *in Paramount Pictures*

COME UP AND SEE ME SOMETIME

Mae West 1892–1980

Photographer: E. R. Richee, 1934
Degree of difficulty: Fairly easy (2 lights)

The original line was 'Why don't you come up sometime and see me,' but the version we have used became so established in the public mind that Mae West herself started to say it to interviewers in later years – in that inimitable voice that always managed to discount the polite version of a double entendre. She is remembered as much for her wit and one-liners as for her looks. Fed the line 'Goodness, what beautiful diamonds,' in her very first film (*Night After Night*, 1932), she answered, 'Goodness had nothing to do with it, dearie.'

Many pictures of Ms West were somewhat retouched around the silhouette of her body, in order to bring her closer to the 1930s ideal of feminine shape. We chose this picture to concentrate attention on her eyes and mouth. She looks as if she is about to deliver some classic line, such as her observation on being greeted at the studio by a bevy of handsome young men: 'I'm feeling a little tired today. One of you fellows'll have to go.'

When photographing hats, remember that they can be tipped all over the head, at angles that would be completely insupportable if they were actually being worn. This is tipped well back; compare it with the angle of Spencer Tracy's hat on page 57.

The lighting is surprisingly simple and tightly constrained. The key, a big, hard light almost directly over the camera and very slightly to camera left, is as high as it can be without casting too much of a shadow from the hat. The fill, lower and slightly to camera right, is, well, a fill. And that, as far as we can tell, is it.

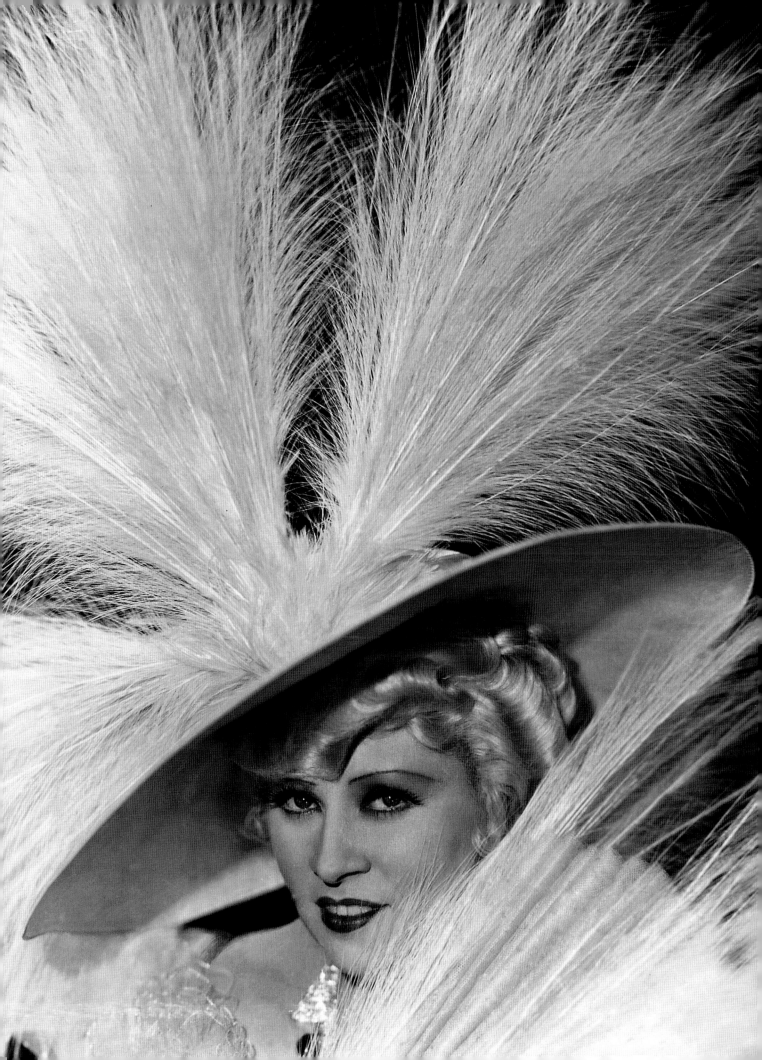

PAID BY THE TEAR

Sylvia Sidney 1910–99
Photographer: E. R. Richee, 1934
Degree of difficulty: Moderate (3 lights)

'Paramount paid me by the tear,' was how Sophia Kosow described her career, playing at first a gangster's moll, then the sister who was bringing up the gangster, and finally the gangster's mother. As she said: 'They always had me ironing somebody's shirt.' She made her first movie (*Through Different Eyes*) in 1929 and continued thereafter for a very long time, even appearing in such films as *Beetlejuice* (1988) and *Mars Attacks* (1996).

For a shot like this, a flawless complexion is a major asset, though a great deal can be done with make-up and even more can be done by a skilled retoucher. It would be very interesting to try this sort of shot with a girl of twelve or even younger, though 'loop' lighting on a very young face is often defeated by relatively unformed noses.

There seem to be two lights on Ms Sidney: the key, the 'loop' light to camera right (look at the nose shadow, which gives the light its name), and a fill alongside the camera at camera left, although it is possible that there is no fill. There may be a third light on the hair, but spill from the background would probably be sufficient to provide the highlights.

The background is perhaps overly dominant and is arguably overlit, probably with a single spot. Most photographers today would aim for a little tonal differentiation between the fur and the background, though its absence may be the result of this being a second- or third-generation copy.

Key

Fill

Background light

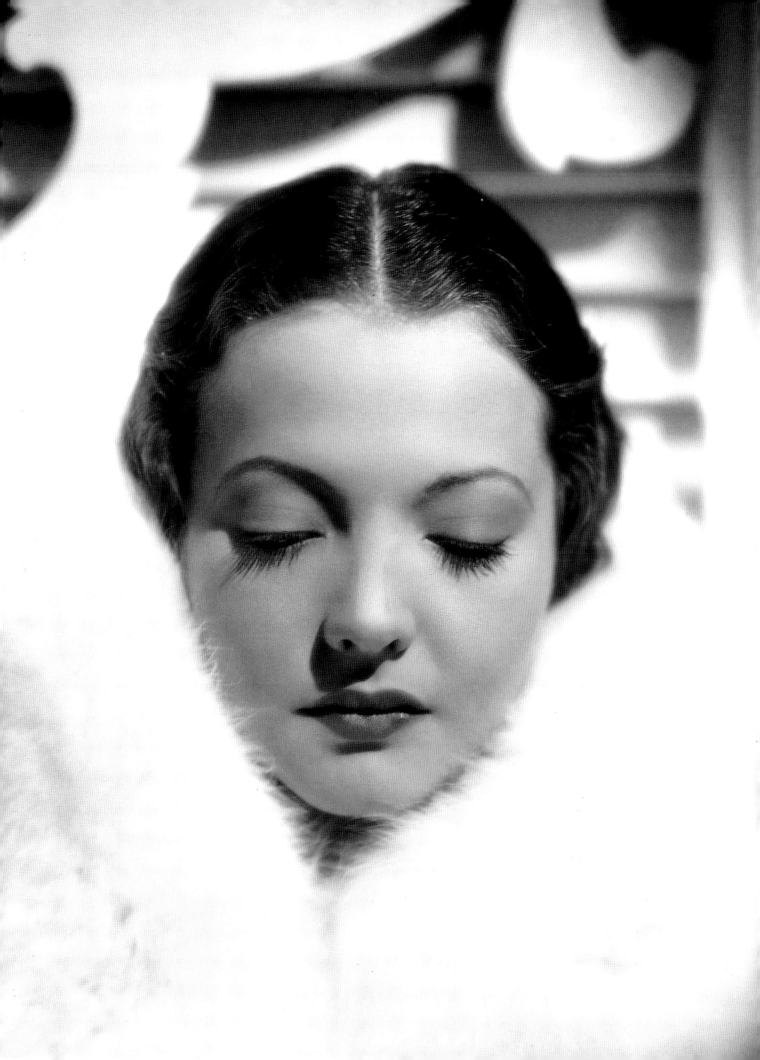

TOP HAT AND TAILS

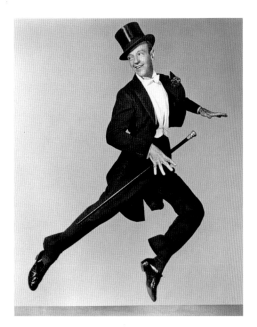

The best date we have for this picture is 1951, and C. S. Bull may have been the photographer; both of which observations are less remarkable than the fact that Mr Astaire was over 50 at the time. The only way we can see to achieve this picture is with powerful, high-voltage electronic flash. This light is just above his eye-line: look at the hat shadow, and the reflections on cane and shoes. Everything in the picture is as sharp as it can possibly be expected to be, and this would simply not be achievable with any shutter or film available at that time, plus continuous lighting. However, it is possible that the background is continuously lit with an immense wattage, or even that the flying star was 'comped' into the background using (pre-digital) image manipulation techniques.

Fred Astaire 1899–1987
Photographer: Ernest Bachrach, 1935
Degree of difficulty: Moderate (4 or 5 lights)

After he changed his name, Frederick Austerlitz became a byword for cinematic dancing – a well-deserved reputation, which never really declined. After starting in vaudeville, he moved to the silver screen when his sister, Adele, retired in the early 1930s, first with MGM in 1933, then later with RKO, where he made his best known pictures alongside Ginger Rogers.

The pose is a cliché, but it is supposed to be. Fred Astaire's entire persona was unique, and dressing like some *fin-de-siècle* man-about-town was something that he could carry off better than anyone else. The chiaroscuro and the arrangement of light and dark areas are masterful: the lit side of his face is against dark, the dark side against brightness (with a rather awkward-looking ear, it is true), and the face itself is set off by the dark hat above and the white shirt and tie below. This sort of use of tones can be adapted to many other subjects.

The key is clear enough, from camera right, just forward of the subject and very slightly above his eye level. A second light from camera right, low and further forwards, lights his left hand and arm, and creates the faint diagonal shadow running across the chest. There may also be a hair light on the right, although the hair effect looks more like bad retouching. There is a fill, low on camera left – look at the second reflection in the ring – but it is very weak. Finally, there is a background light, probably a scrim, presumably between two flats.

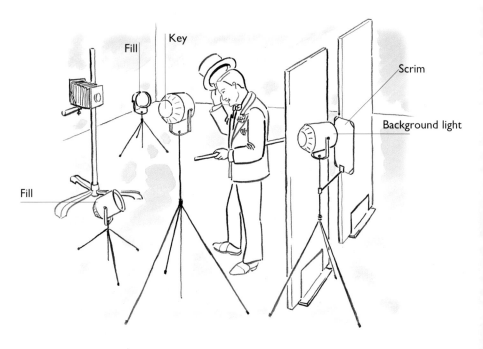

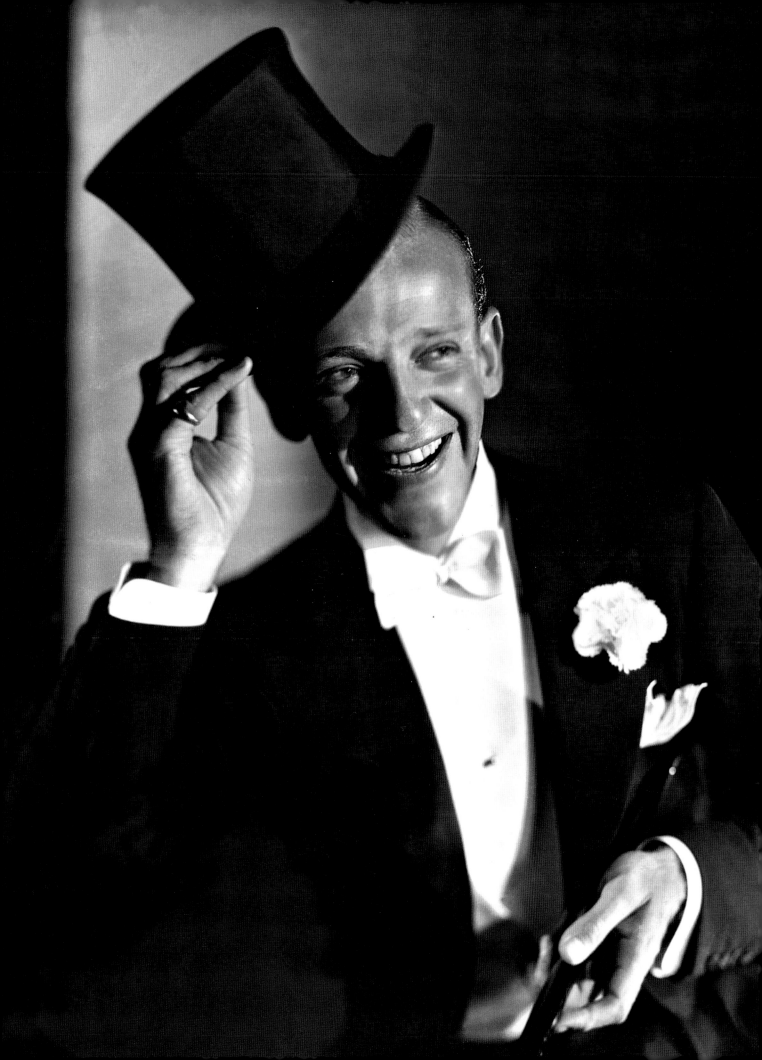

LASZLO WILLINGER

Laszlo Willinger, 1982, with prints of some of the stars he photographed over the course of an incredibly packed and varied career.

Born in Budapest, a Hungarian as one might guess from his name, Laszlo Willinger (1909–95) was a man of formidable energy and talent; the sort of person whose *curriculum vitae* is so crowded that you wonder how he managed to fit it all in or whether you are reading two separate accounts of two separate photographers that were by some mischance run on the same page.

His mother was a photographer, and his father was the owner of a news agency, so it is small wonder that he became interested in photography in his teens. It is a little more surprising to learn that in 1927, when he was still only 18, his books *London* and *Berlin* were published, or that by 1929 he had set up his own studio, first in Paris when he was 20, and later in Berlin.

In the early 1930s, while in his early twenties, he also worked as a freelance photographer for *Berliner Illustrierte*, *Hamburger Illustrierte*, and *Münchener Illustrierte*, though in the mid-1930s his photographs in German publications were credited to his mother, Margaret Willinger, because he was *persona non grata* with the Hitler regime. He left Berlin when Hitler became Chancellor in 1933, but at his studio in Vienna (1933–37) he photographed numerous celebrities from all walks of life, including Marlene Dietrich and Hedy Lamarr, Sigmund Freud and Carl Jung. By the late 1930s the *Daily Express* in London had published his pictures from Africa, Italy, India, and Russia – and the Spanish Civil War. He was still not yet 30.

In 1937, five years after his first visit to the United States, he emigrated and started to work for MGM after being 'discovered' by E. R. Richee, a well-known Hollywood photographer whose work appears in this book. From 1946 to 1954 he was running his own studio again, one of the earliest to specialize in color photography, concentrating on Hollywood subjects; but after 1954 he characteristically broadened his fields of interest once more, working in an enormous range of advertising, portraiture, magazine work, and publicity.

His work shows clear influences of the artistic ferment in which he grew up in Europe in the 1920s and of the highly intellectualized and formalized Berlin (and Soviet) school, but there is also a strong reportage strain. He was one of the first Hollywood photographers to use hand-held cameras extensively, which is perhaps why his pictures are not as well-known as those of some others: they lack the repose that 8 x 10 in. customarily forced on its subjects. Although he was a man of his time, Willinger was also, to a considerable extent, a man who lived, in the first half of the twentieth century, a life that was much better fitted to the second half: international, multi-skilled, ever willing to change and learn. Others may have made their name in Hollywood: he made his name in a dozen different places, often at the same time.

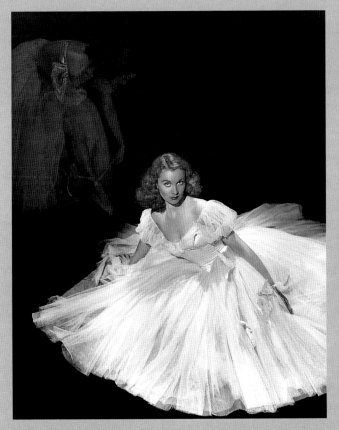

Vivien Leigh, 1940. A plain double exposure, giving each figure the same 'weight,' would not have had the impact of this one, where the smaller secondary figure is under-exposed to create an almost ghost-like form. Willinger was one of the few Hollywood photographers with both the imagination and the technical expertise to create such an image.

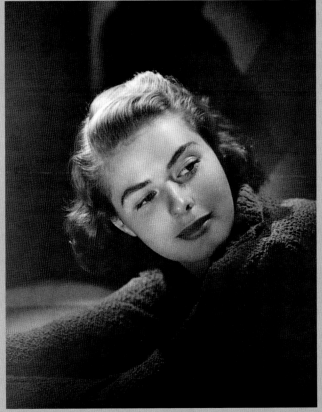

Ingrid Bergman, c. 1941. The use of shadows on the background is a Hollywood cliché, in some cases as much because of technical incompetence as because of the photographer's vision. But such an accusation could never be levelled at Willinger. The almost cubist use of light and shadow here is the work of a master.

HOW OLD CARY GRANT?

...

Cary Grant 1904–86
Photographer: Robert Coburn, 1935
Degree of difficulty: Moderate to hard (5 lights)

Archie Leach's perfect reply to the cabled question 'How old Cary Grant' was 'Old Cary Grant fine, how you?' In this shot, a less clever answer is that he is 30 or 31, already over a dozen films into his career, with another third of a century or so of filmmaking ahead of him.

The pose can be held comfortably for quite a long time, without the risk of losing focus in the interval between closing the shutter and exposing the film. To ensure that the pose is right, frame your subject in a pose that precludes movement outside the frame (as here), make the camera ready for the exposure, then watch the subject without using the viewfinder, directing eye movement and the like, and pressing the shutter release when you are completely satisfied.

Note the strip of dark background, placed asymmetrically behind the head. Imagine the background as plain white, or as textured but identical from left to right, and you can see the disadvantages of both seamless paper and textured and painted fabric backdrops.

Rather a lot of lights were used in this picture: five or possibly six. Usually, this many lights is a sign of desperation, and conflicting shadows abound, but not here. The key – look at the nose shadow – is well to camera left, and somewhat above eye level. A fill, slightly to camera right, is evidenced by the larger catchlight. Two hair lights/kickers are used, one above the subject, the other above the subject and to camera right. Finally, there is at least one light on the background: flags have been used to darken the lower corners so that the sweater does not disappear into the background on the right of the picture and for balance on the left.

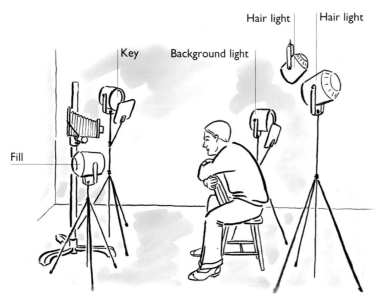

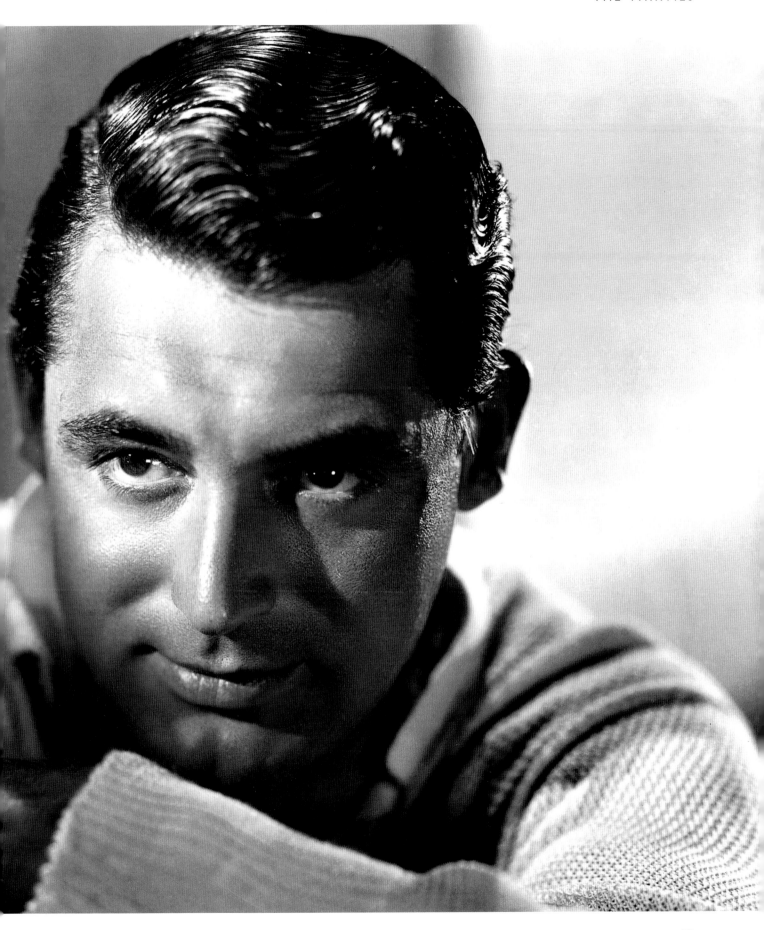

CHILD STAR

Shirley Temple b. 1928
Photographer: Frank Powolny, c. 1936
Degree of difficulty: Moderate (3 lights)

Shirley Temple was already appearing in short films at the age of three, and by the age of six, she was a genuine star. Her movie career was slowing down at an age when her contemporaries were just becoming known, and in her thirties she went into Californian politics before receiving a number of ambassadorial and other political positions from the 1970s onwards.

No sane modern photographer would even consider photographing small children with an 8 x 10 in. camera, but then, few modern children are the consummate professionals that Ms Temple was. Depth of field is very shallow, indicating a wide aperture, and there is lots of diffusion, whether achieved with a soft focus lens or with gauze in front of the lens. The eyes, with their enormous irises, are interesting: an older model probably could not look as good when looking so far to one side.

The key is slightly to camera left, slightly above Ms Temple's eyeline: look at the nose shadow (though this is shorter than it would be in an adult, because of her childish features), the shadow of the upper lip, and the upper catchlight in the eyes. Unexpectedly, the fill is also to camera left, but much lower: look at the second catchlight. The background is lit with at least one shaped spot (snooted or shaped with flags), and spill and reflections from this probably account for the lighting on the hair.

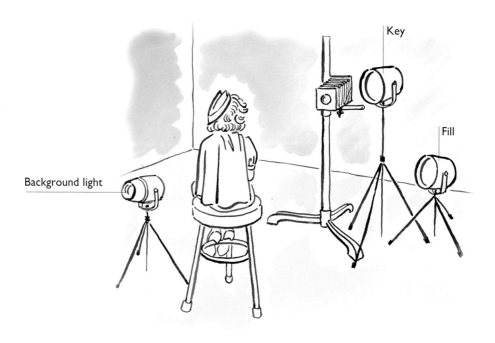

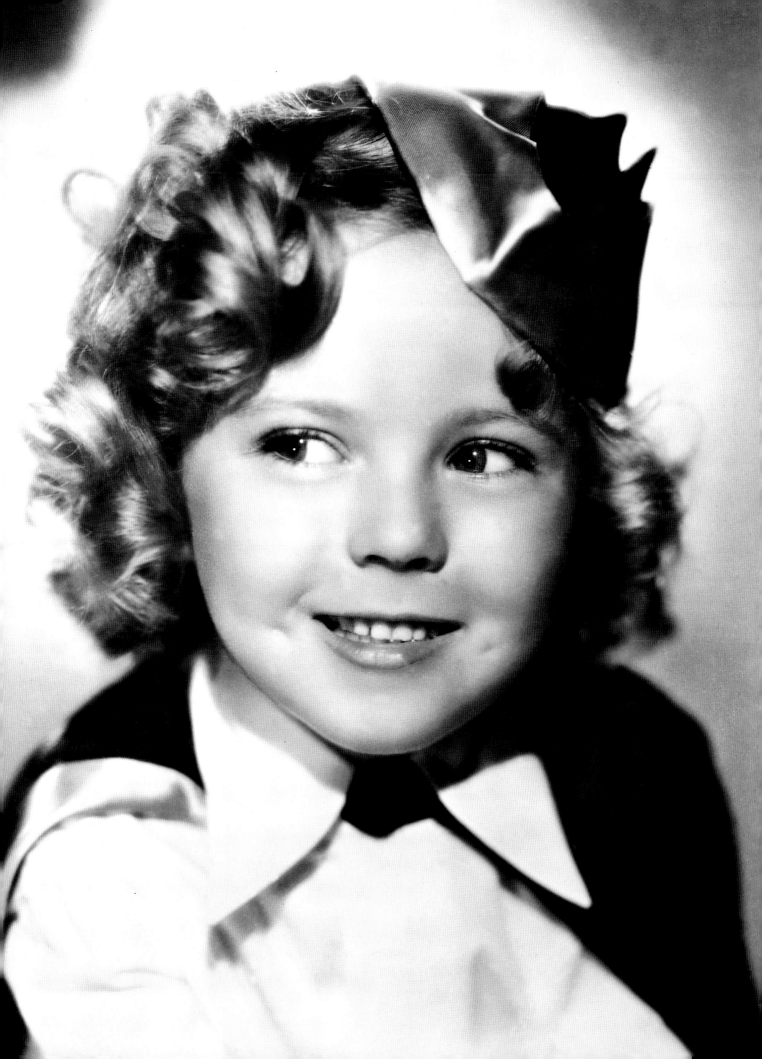

FALLING IN LOVE AGAIN

..

Marlene Dietrich 1901–92

Photographer: George Hurrell, 1936
Degree of difficulty: Fairly easy (4 lights)

Two of Maria Magdalena Dietrich's movies came out in 1936: *Desire* and *The Garden of Allah*. Marlene was 35 in that year; *Der Blaue Engel* was six years past, and *Destry Rides Again* was three years in the future. Hurrell was running his own studio at the time, in the six-year gap between MGM and Warner Bros.

The use of chiaroscuro is masterful: light against dark, dark against light. With light alone, Hurrell creates a dark frame around Dietrich's face and shades her hand until the fingertips are a pure silhouette – although close examination of the original print reveals that the definition of the fingers (and indeed of much of the hand) owes a very great deal to retouching, probably to counteract unsharpness resulting from limited depth of field.

Compositionally, a strong use of horizontal lines makes for a languid effect, while the props all suggest luxury and even decadence: the textured background, the leather chair, the sequined dress.

Compared with many Hollywood portraits, this would be comparatively easy to re-create. The key light, a spot, is high and central: look at the shadows of the nose and eye sockets. From the evidence of the arm, there may also be a fill from above, and possibly even a third light, a very tight spot as a hair-light: so hot that the top of the hair is burned out, as are parts of the sequinned dress. A set of background lights – probably three, again spots, again from above – completes the lighting.

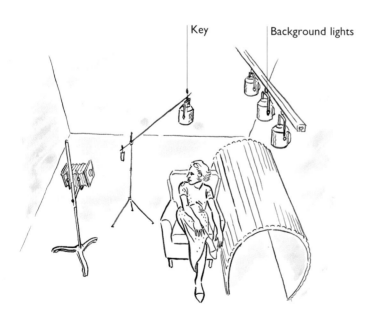

Key Background lights

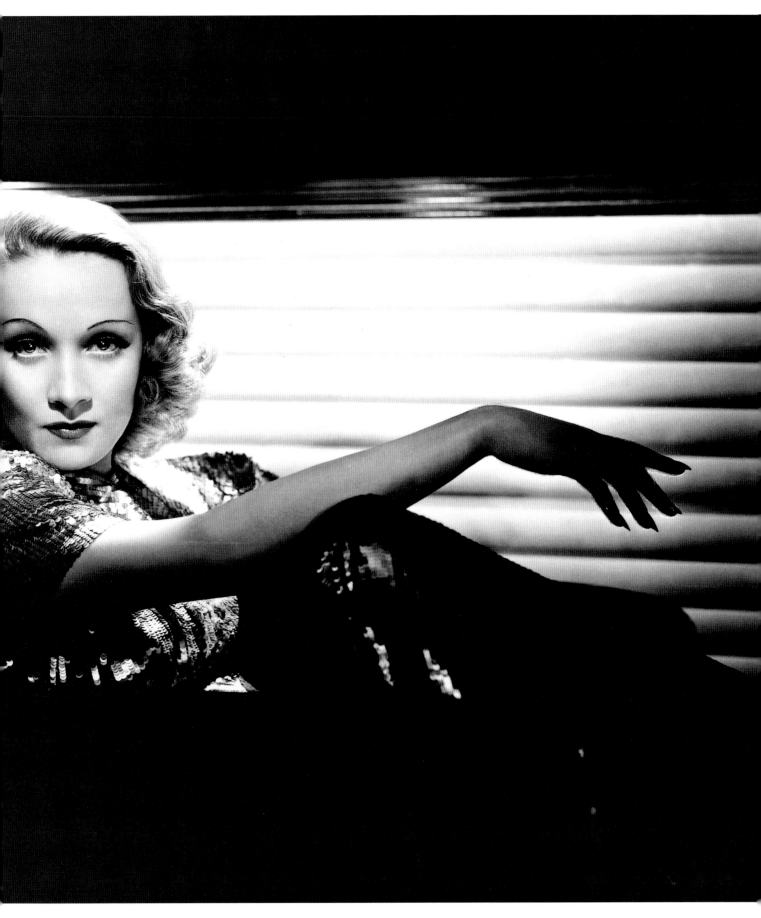

IN LIKE FLYNN

Errol Flynn 1909–59

Photographer: Not recorded, 1937
Degree of difficulty: Easy, except for retouching (1 light)

Errol Leslie Thomson Flynn was a hell-raiser of the deepest dye, who shared a house known as Cirrhosis-by-the-Sea with David Niven. As far as we know, he is the only major Hollywood star ever to hail from Tasmania.

We chose this portrait, rather than one of the more obvious costume shots, partly because it illustrates an interesting technique and partly because costume shots on set are of limited use to the photographer who wants to re-create a portrait with another subject. If the set costs thousands to reproduce, this will render the lighting of academic interest to most portrait photographers.

Note how the pipe is seriously out of focus: if it were in the plane of focus, it would cast an extremely awkward shadow. Anyone trying to re-create this picture with roll film or 35 mm would have to decide for themselves whether to use a very wide aperture and leave the pipe out of focus, or to keep it in focus. It would also be possible to make a case for using a weak backlight to provide more roundness in the pipe.

The picture is heavily retouched and it is disputable how much of the smoke was actually there on the unretouched negative. On the other hand, the shape of the nose and cheeks was achieved by lighting alone, and the effect is well worth studying.

A single spot is flagged to a tall, thin strip of light by using two flags. The light is slightly behind Mr Flynn's face, though obviously, the final effect was almost certainly achieved by asking him to move his head slightly rather than by moving the flags.

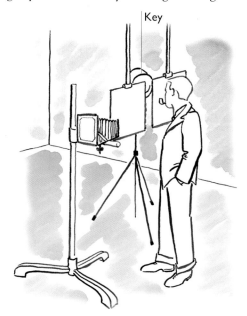

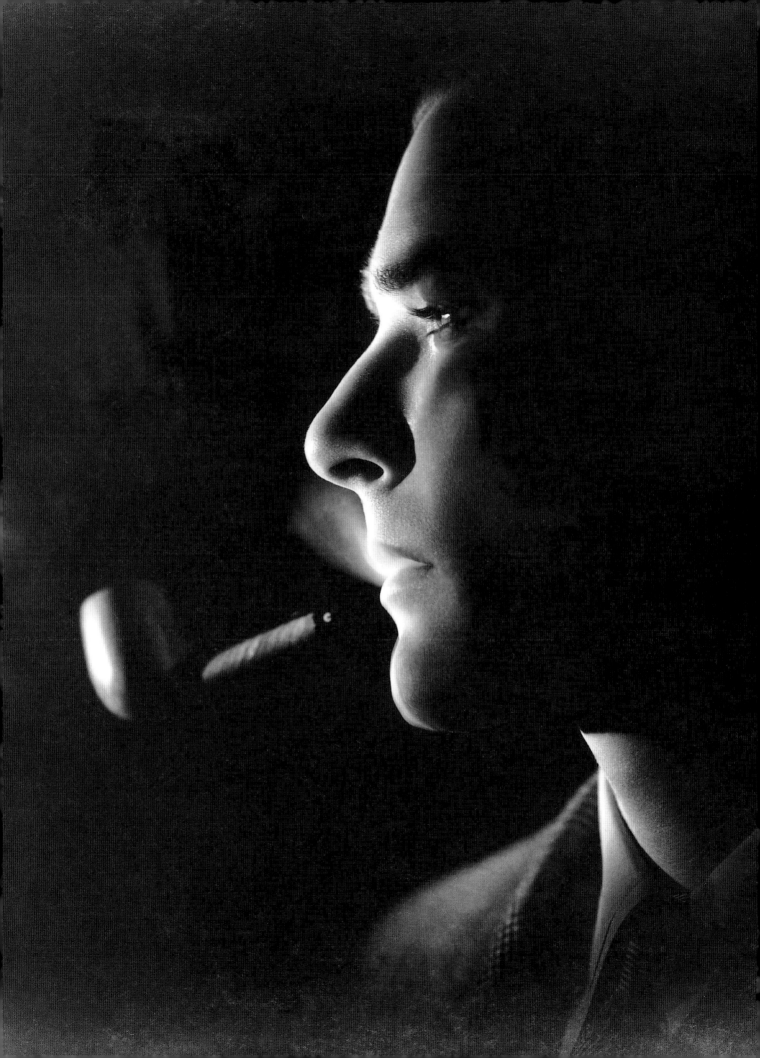

OZ AND BEYOND

Judy Garland 1922–69
Photographer: Laszlo Willinger, 1937
Degree of difficulty: Quite easy (3 lights)

Frances Gumm was born into a vaudeville family and appeared on stage when she was five, though her first movies were not made until she was in her teens, and only in 1939 was she given a special Academy Award 'for her outstanding performance as a screen juvenile.'

The camera is almost certainly tilted dramatically in this picture. This was partly a matter of Hollywood fashion – cameras were often tilted – but the trick has other uses as well. The hair can be made to fall forwards or back, according to the angle of the subject's head, while the apparent angle in the frame is controlled by the camera, and awkward straining of the neck, skin, and so on can be avoided. To appreciate the true position of the lights, tilt the picture so that the upper left corner is directly above the lower right corner.

With a large head portrait like this, depth of field can be a problem, even with roll film, and with an 8 x 10 in. camera, it would require considerable movements – though the use of plenty of soft focus helps to disguise unsharpness. This picture may even have been shot through gauze to soften the image still further.

The key is to camera right, slightly behind Ms Garland: the shadows of the nose and upper lip reveal this. A light in a large reflector would suffice. The fill is probably just below the camera: look at the highlights on the teeth and the catchlights in the eyes. For this, a rather smaller reflector (and a weaker light) would be needed. A third light illuminates the background. This is as simple as a three-light portrait can be, but it does illustrate the importance of lighting the background.

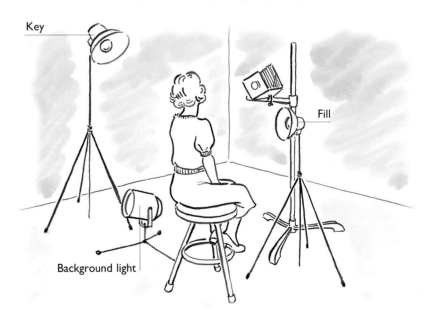

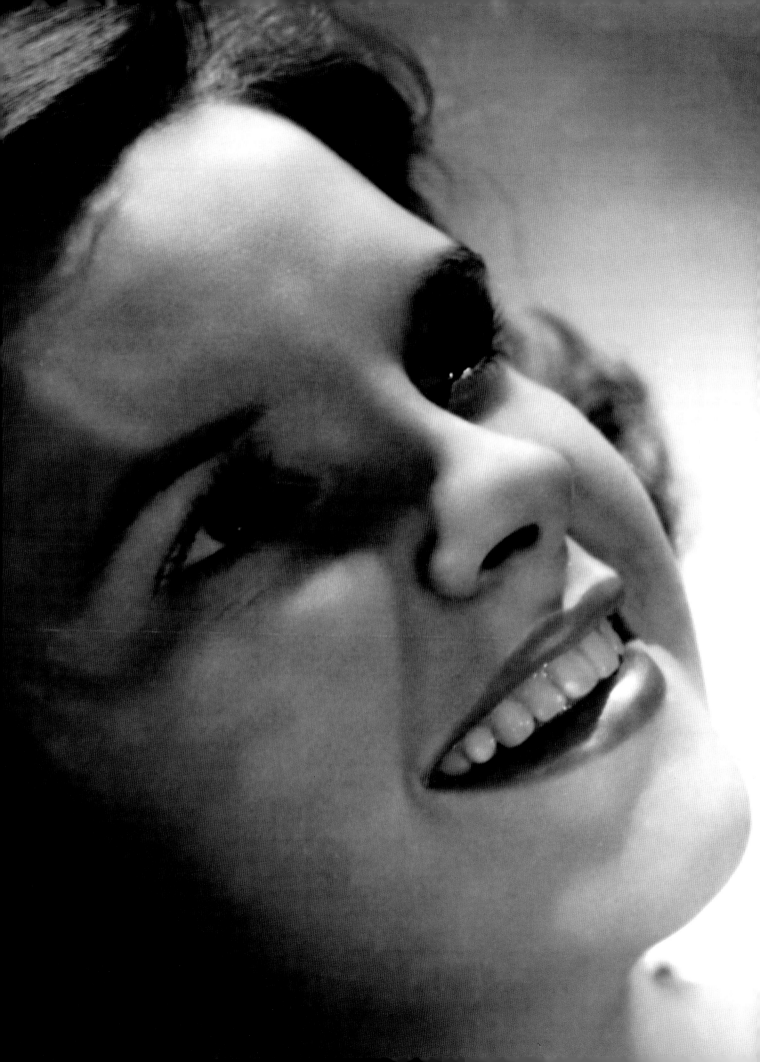

I PLAY JOHN WAYNE ...

John Wayne 1907–79
Photographer: Robert Coburn, 1938
Degree of difficulty: Easy (2 lights)

Marion Michael Morrison was the archetypal Hollywood cowboy and action hero, though it could fairly be said that he was a star long before he learned to act. In *True Grit* (1969) he was, without doubt, both a star and a great actor; in *Stagecoach* (1939), for which this is a publicity shot, with the actor looking younger than his 31 years, he was more of a star. But then, as he said himself: 'I play John Wayne in every picture regardless of the character, and I've been doing all right, haven't I?' Although his movie career began in 1927, it was not until 1930–31 that it really took off, and by the time *Stagecoach* was made he was well established in the Hollywood firmament.

One of the most remarkable things about this shot is the precision of the framing, with the edge of the hat so close to the edge of the picture. Mr Wayne was almost certainly upright, with the camera tilted to create the pensive, downward-looking pose: this would be much easier to hold. Another useful trick, which Robert Coburn may or may not have used, is to put a lighting stand or a bamboo cane or something similar behind the hat, out of shot, so that when the rear of the brim was against the upright object, the front was where he wanted it. The set of the jaw is emphasized because it is skimmed by both lights.

This is a straightforward two-light portrait. The key is almost dead level with the subject, to camera left: it is set as high as possible, without the shadow of the hat obscuring the eyes. The fill/kicker, to camera right and behind the subject, differentiates the hat (white, of course) from the background and stops the hair, neck, and bandanna (and a tiny part of the ear) from disappearing into blackness.

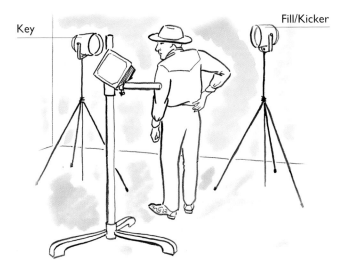

Key

Fill/Kicker

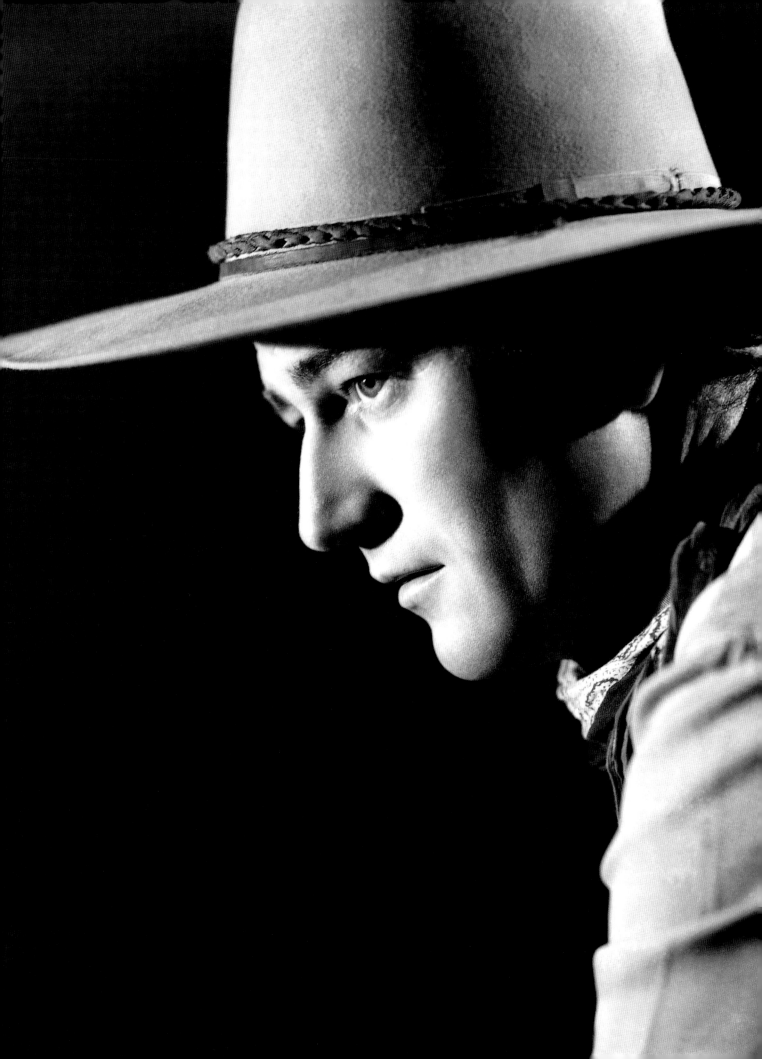

THE OOMPH GIRL

Ann Sheridan 1915–67
Photographer: George Hurrell, 1938
Degree of difficulty: Easy (2 or 3 lights)

Clara Lou Sheridan made her name in a beauty competition, but went on to become an enduring and well-loved star. The moniker 'The Oomph Girl' owes perhaps a little too much to Hollywood's predilection for repeating a winning formula, especially if it could be condensed to a short slogan – remember Clara Bow ('The It Girl') and Lana Turner ('The Sweater Girl') – but with more than three score and ten movies to her credit, her acting credentials are clear enough.

Neither of these pictures can be said to do justice to Ms Sheridan's looks, though the images are certainly dramatic. With a less beautiful subject, an even more horrific effect would be entirely likely. In the larger picture, the camera is almost certainly tilted. If you hold the picture so that the upper left corner is directly above the lower right, this is probably the actual pose: certainly, it is what we have drawn. If we are wrong, and her head and body really were tilted, it is not hard to work out the lighting plot for yourself. The plane of focus is masterfully controlled to hold both the bracelet and Ms Sheridan's face.

The strong light to camera right has the best claim to being the key; the even stronger light to camera left is more of a kicker. Both are probably 'feathered' – that is, the photographer was working with the edge of the beam. There may also be a weak background light to explain the light patch above the left shoulder. A spritz with the airbrush could create much the same effect, but if you were trying to re-create the picture, lighting would probably be the way to go.

In this picture from the same shoot there is a key from below and camera left, plus at least one back light, again from camera left. There may be two, as evidenced by the hair on the right of the picture, but we doubt it.

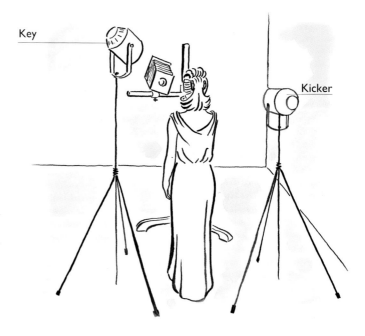

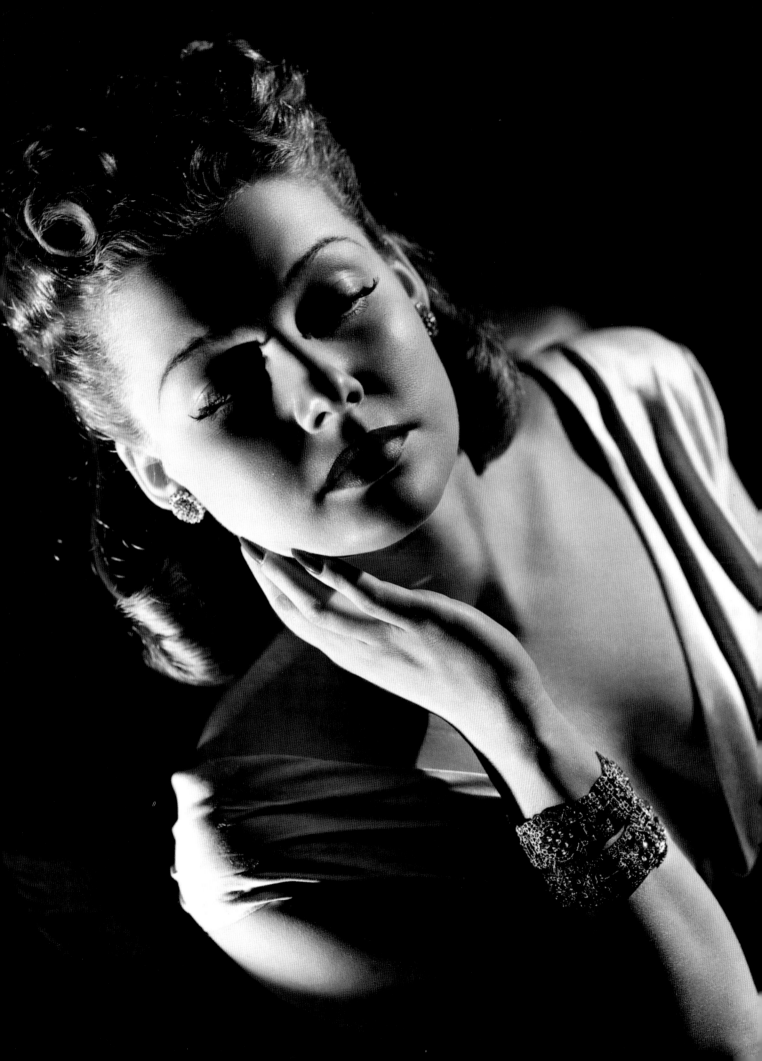

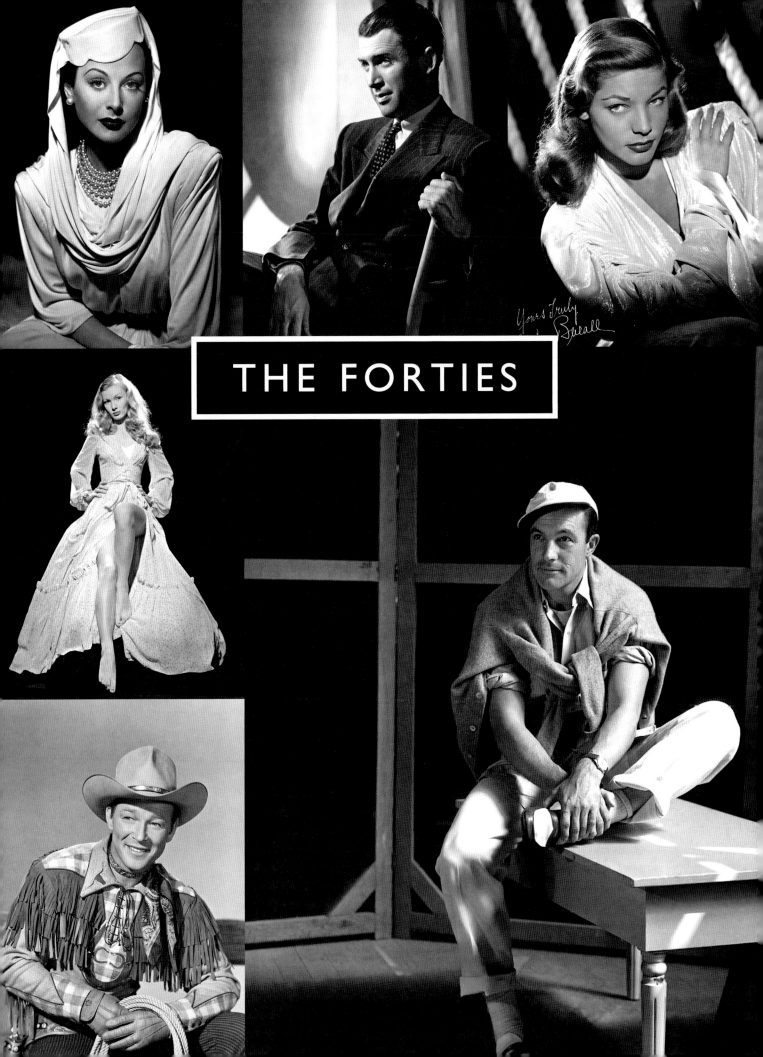

THE FORTIES

Yours Truly
Bacall

THE FORTIES

Our first chapter ran from the 1910s to 1930. The second ran from 1931 to 1939. Now, we embark upon the period 1940–49. We apologize for having (as accountants say) changed our accounting base, but the apparent inconsistency is a reflection of the fact that calendar decades are at best approximations to Hollywood's epochs and to the world's concerns. The vast majority of Hollywood movies are, and always have been, escapism; but at different times they have provided escape from different things.

It is all too easy to forget what a narrow world was inhabited by the vast majority of people living in the early decades of the twentieth century. Surprisingly few, even in the most affluent countries, had access to

a telephone, travel for more than a few miles was substantially the prerogative of the wealthy or the simply footloose, and there was a widespread and desperate yearning for the world beyond the farm, the small town, or the rigidly formal shop or office. This was the first escape that Hollywood provided. Initially, the mere novelty of seeing a moving picture was enough, though early on plots and indeed epic themes were adopted, as in *The Birth of a Nation* (1915).

Then, in the 1930s, there was the Depression. What people needed to escape from now was not the grind of work and narrow borders: it was poverty, real or feared. Extravagance, both on screen and in accounts of the lives of the stars, mirrored the dreams of those

The trench-coat and revolver are a distillation of the film noir of the 1940s, although the chiaroscuro is less dramatic than in most of the moving pictures in that style. Presumably, E. R. Richee, who took this picture of Alan Ladd in 1942, wanted something a little more conventional. The rendition of texture and detail is exceptionally good for any Hollywood portrait.

Like the picture of Alan Ladd, left, this 1946 picture of Rita Hayworth by Robert Coburn demonstrates exceptional texture and shadow detail, although the hottest highlights are slightly burned out. There is still a fair amount of retouching, especially around the edges of the cheeks, but the overall effect is much more natural than most of the pictures from the 1930s.

A long way from any Hollywood formula, this 1945 portrait of Jennifer Jones by John Miehle uses a single light and (at a guess) an 8 x 10 in. camera to create a unique and memorable image. It may or may not be visible in reproduction, but there is a four-way 'starburst' in the highlights in the eyes, most visible in Ms Jones's left eye. It appears to have been added in the modern way, with an effects screen, rather than by retouching.

who had little or nothing. By the end of the 1930s, many Americans (though far from all) had perceived the dangers that Hitler posed: Hollywood, with its strong Jewish contingent, was rather more aware than some on the East Coast, where pro-Nazi sentiments were not unknown. When war came for real, the excesses of the 1930s seemed somehow unpatriotic: a tougher, more realistic style developed, with stills photography to match.

Technically, little had changed since the introduction of the films described in the last chapter opening, and the 8 x 10 in. camera still ruled the roost. Soft focus was almost forgotten, though retouching was still rampant. Lighting was in danger of becoming formulaic, to such an extent that the terms 'loop' and

'butterfly' (both referring to the shape of the nose shadow) became shorthand for well-known lighting styles. Even so, there was still plenty of variation, and until 4 x 5 in. and even roll film began to play an ever greater part from the very late 1940s onwards, there was still a very recognizable Hollywood style.

An odd aside is that although we tried to keep a reasonable balance between male and female portraits, the 1930s turned out to be kinder to men, and the 1940s to women. One could, of course, argue that the war put something of a dent in the demand for old-fashioned action heroes: at least some were sometimes expected by the public to stop acting and to take up in real life the roles that had earned them fame and fortune on the silver screen.

SCARLETT WOMAN

Vivien Leigh 1913–67
Photographer: Laszlo Willinger, 1940
Degree of difficulty: Fairly hard (4 lights)

Vivian Mary Hartley's first movie, *Things Are Looking Up*, was made in 1934, but when people talk about her starring role in *Gone With the Wind* in 1939 – for which, of course, she won an Academy Award – she is still commonly referred to as 'an unknown actress.'

We see, as so often, a fairly easy-to-maintain pose, the more so if there were cushions below and behind Ms Leigh to support her further. The importance of the luxurious, partly off-the-shoulder gown should not be underestimated: it would be much more difficult to make such a pose and such lighting work with jeans and a T-shirt, though an artfully draped *pashmina* or even a few yards of butter muslin could probably work wonders.

There may be a tiny amount of diffusion here, or it could simply be the result of an uncoated lens and a fair acreage of white or near-white fabric: do not underestimate the importance of flare in classic Hollywood portraits. We make these points merely as a reminder that lighting alone is inadequate to explain the Hollywood Look – although it should be entirely possible, with roll film emulsions, such as Ilford's Delta 100, to achieve a tonality that would, when this picture was taken, have cried out for a much larger format.

The key is classic 'butterfly' lighting: high, fractionally to the right of the camera–subject axis, and well above the camera. The main fill is to camera left; the soft light above the head functions partly as a fill but was probably intended as a hair light. It casts an unfortunate shadow on her bosom. A fourth light, directly behind her, backlights the hair, though it might be easier to use two hair lights.

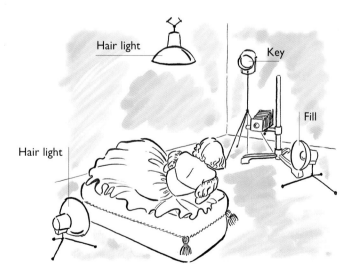

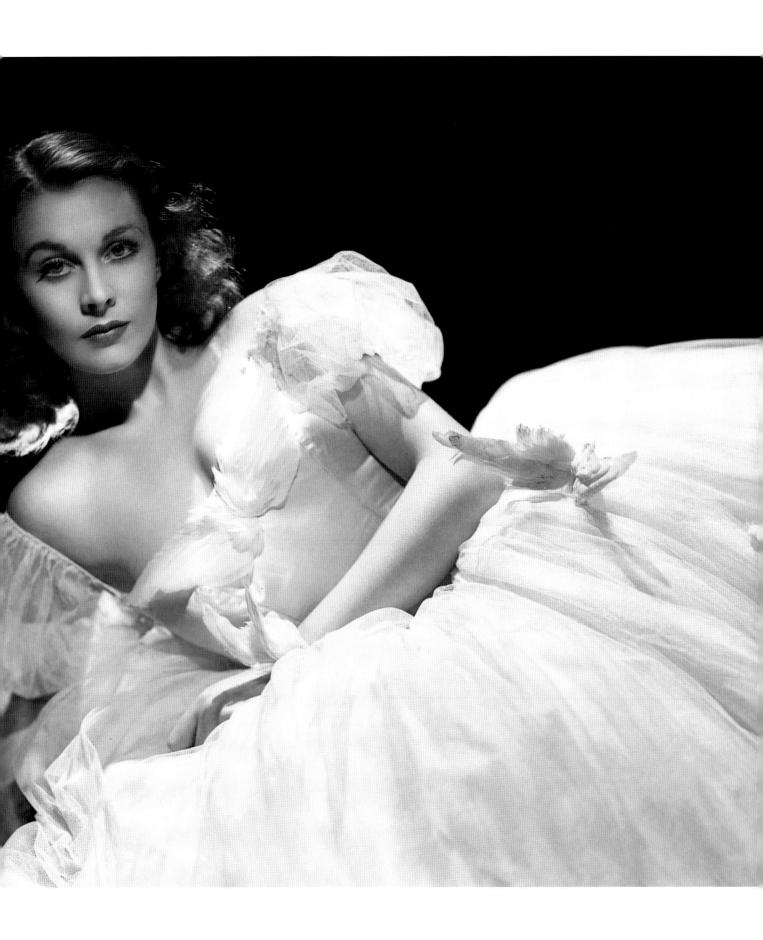

A GIRL IS ... A GIRL

..

Rita Hayworth 1918–87
Photographer: A. L. 'Whitey' Schafer, 1940
Degree of difficulty: Fairly easy (4 lights)

Margarita Carmen Cansino first appeared on the stage as a 12-year-old and appeared in her first four films in 1935. Early publicity material made much of her exotic ancestry – her father was a Spanish gypsy dancer – and called her Rita Cansino. Not until she was dropped by Fox and signed with Columbia, however, did she find stardom. She said of herself: 'A girl is ... a girl. It's nice to be told you're successful at it.'

Traditionally, portraits shot from below the subject's eyeline are used to increase dignity and gravitas and are in consequence commonly reserved for men. The high 'butterfly' lighting minimizes the nostrils, which can easily look like gun barrels from this angle if too brightly lit, and the shadow under the chin helps to isolate the face against dark masses of tone. The shoulder highlight is a little 'hot' and might have benefited from a dab of translucent powder, and a better background might have been found than what seems to be an out-of-focus prop. The reflections in the pearl-like drops are almost certainly a consequence of the stones' inherent properties and of the lighting, rather than of using a 'starburst' filter or muslin across the lens.

The basic lighting is 'butterfly' with a fill low and to camera right. If it were to camera left, it would have filled the throat shadow more and weakened the chiaroscuro. The hair light and the left shoulder are probably the same backlight to camera left, and there may be another high hair light. The prop behind her head is separately lit, but it is probably as well not to dwell on this.

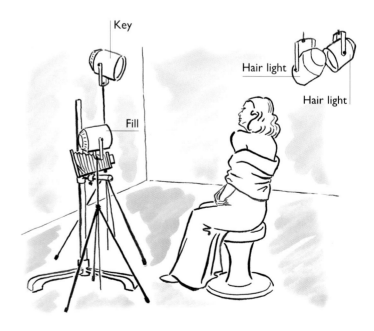

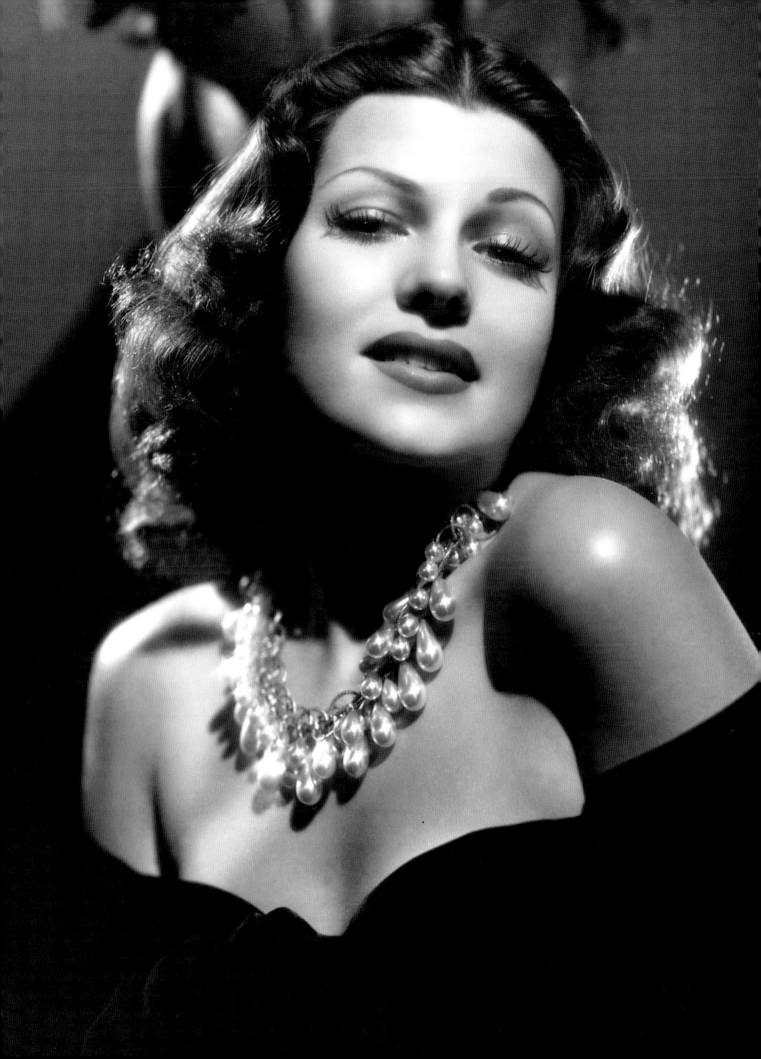

CITIZEN WELLES

Orson Welles 1915–85

Photographer: Ernest Bachrach(?), 1941
Degree of difficulty: Moderate to hard (3 lights)

George Orson Welles made his mark in 1938 when he broadcast a dramatization of H. G. Wells's *The War of the Worlds* over the radio as if it were a news bulletin and caused widespread alarm and even panic. In 1941, *Citizen Kane* caused almost as much of a stir and received even more critical acclaim.

The lighting here is particularly interesting as it is one of the few Hollywood portraits of a major personality that reflects trends outside the United States. The diagonal splash of light across the background, the strong, clear, tilted diagonals, the shadow, seemingly arbitrarily, across the face – all of these call to mind German and Soviet photography rather than Hollywood. The camera is almost certainly tilted, so the boards at upper right are actually vertical.

Composition and lighting are such that you could re-create the shot on 35 mm without losing anything. Indeed, a modicum of grain might make the shot more dramatic. It is worth knowing, too, that a slide projector offers remarkable scope for re-creating the effect of a Hollywood focusing spot. If edges are too sharp, just throw the gate of the slide projector, or whatever you have put into it, out of focus.

The key is high and to camera right, flagged across the chin to focus attention on the eyes. A fill to camera left gives almost flat lighting on the face, casting the shadow on the neck, and giving the second catchlight in the eyes. The background must be some distance away to be so clearly lit: spill from the other lights would degrade the pattern of light and dark if it were any closer. It would be difficult to find enough height for the background to re-create this picture.

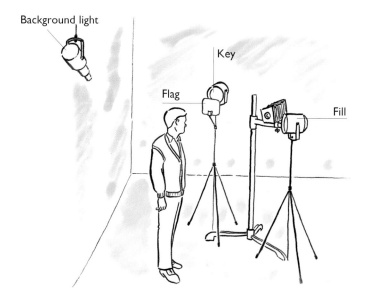

Background light

Key

Flag

Fill

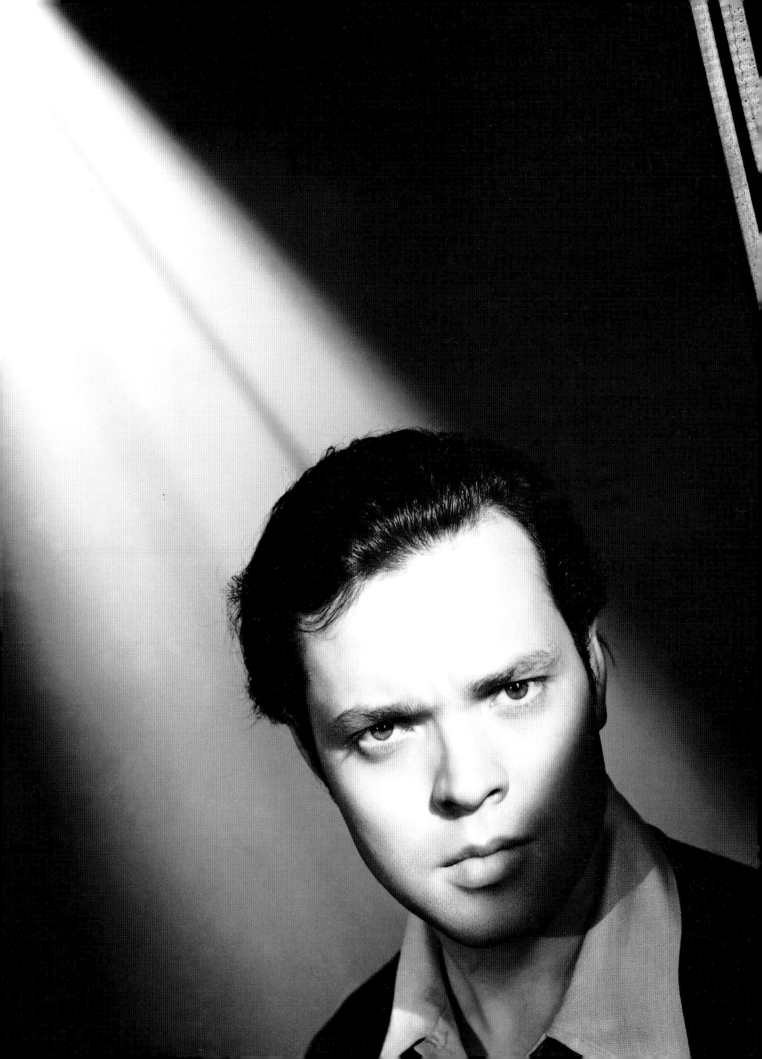

HE THINKS HE'S BOGART

..

Humphrey Bogart 1899–1957
Photographer: 'Scotty' Welbourne, 1942
Degree of difficulty: Moderate to hard (4 lights)

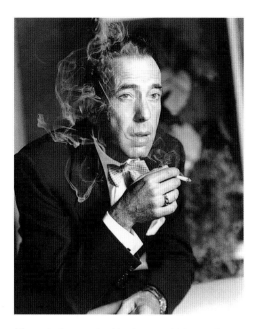

The main interest in this picture, which was shot in 1950 by Coburn, is the way in which the cigarette smoke is rendered 'frozen,' instead of a diffuse blur, as it appears in a number of other shots in this book. This was almost certainly done with flash, probably electronic flash.

'Bogart's a helluva nice guy until 11:30 pm. After that, he thinks he's Bogart.' So said Dave Chase, the Hollywood restaurateur, who presumably saw the change-over fairly often. Bogart was, of course, a movie tough guy, but he was an intellectual's movie tough guy, the man who more or less defined film noir, and the personae he created had an immense resonance in popular culture. His mannerisms and style of speech have become shorthand for a particular type of personality.

As so often, the props contribute a great deal to the Hollywood ambience: the fedora, the trenchcoat, the cigarette. The principal drawback in re-creating a picture like this is that it will look like someone trying to play Bogart.

There are two contenders for the key light in this picture, both from camera right. The stronger candidate, set rather below Mr Bogart's eyeline, provides the principal nose shadow and the upper shadow of the cigarette, as well as (we believe) most of the lighting of the coat. The weaker candidate, perhaps better regarded as a fill, is set somewhat higher and provides the other cigarette shadow. Catchlights from both can be seen in his eyes; the shadow on the right lapel is presumably from a flag (not drawn). A third light, the kicker, behind the subject and to camera left, backlights the coat and hat. Finally, there is a background light, again with rods or poles used as flags (not drawn). This is probably the most difficult light to re-create, as it is hard and directional but covers quite a large area.

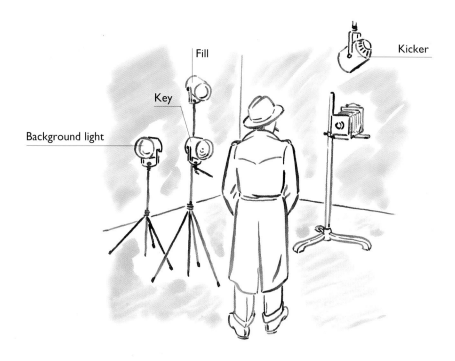

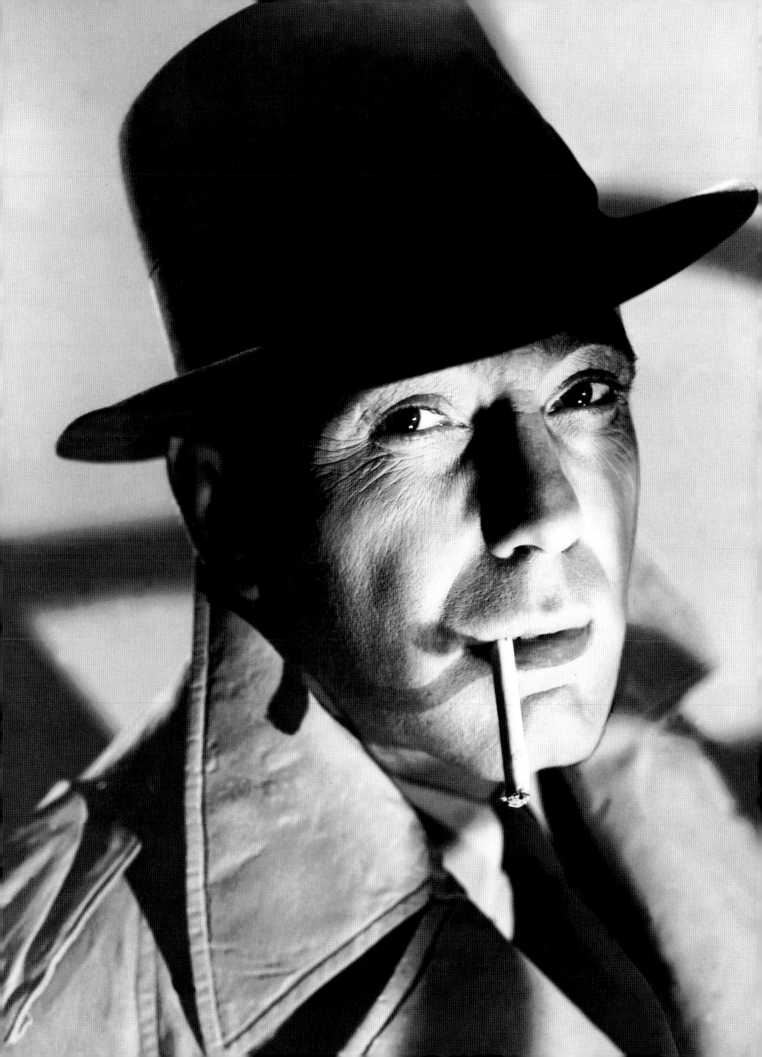

CLASSICAL BEAUTY

..

Lana Turner 1920–95
Photographer: Eric Carpenter, 1942
Degree of difficulty: Moderate to hard (3 lights)

Julia Jean Mildred Frances Turner was reputedly discovered in a drugstore at the age of 15 while cutting school. In 1942, when she was 22 years old, only one movie featured the original 'Sweater Girl:' *Somewhere I'll Find You.*

The chiaroscuro is striking, but there is much retouching in this picture. Most of what we see between the actress and the statue looks like airbrushing, particularly the shadow next to her cheek, but the keyline on the chin is genuine and beautifully executed – a reflection from the background. The props are, perhaps, a little overdone. The intention is to combine sophistication (the gloves, the low-cut gown, the 'classical' bust) and innocence (the flowers and Ms Turner herself). The profile is masterful, and the canting of the camera – a popular device at the time – is all but essential: it places the main subject's face at a more attractive angle and greatly reduces the apparent mass of the statue, which otherwise might dominate the composition. The principal tricks in re-creating this picture are, first, the very careful control of chiaroscuro; second, the angled camera; and third, diligent and extensive retouching.

The key light on the face is the feathered edge of a spot from above and slightly behind the subject. A weaker, less tightly focused spot, acting as a fill, seems to be above the statue. Another strong fill from above and to camera right, slightly in front of the subject, is suggested by the principal shadows of the hand and arm. The latter is probably a spot that is thrown out of focus, with barn doors to darken the torso below the shoulder. The background and some of the skin tones owe as much to retouching as to lighting.

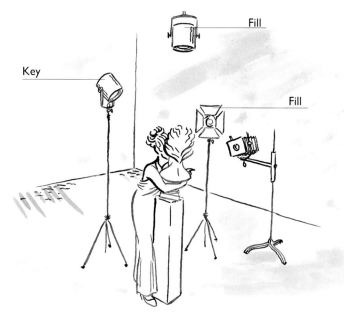

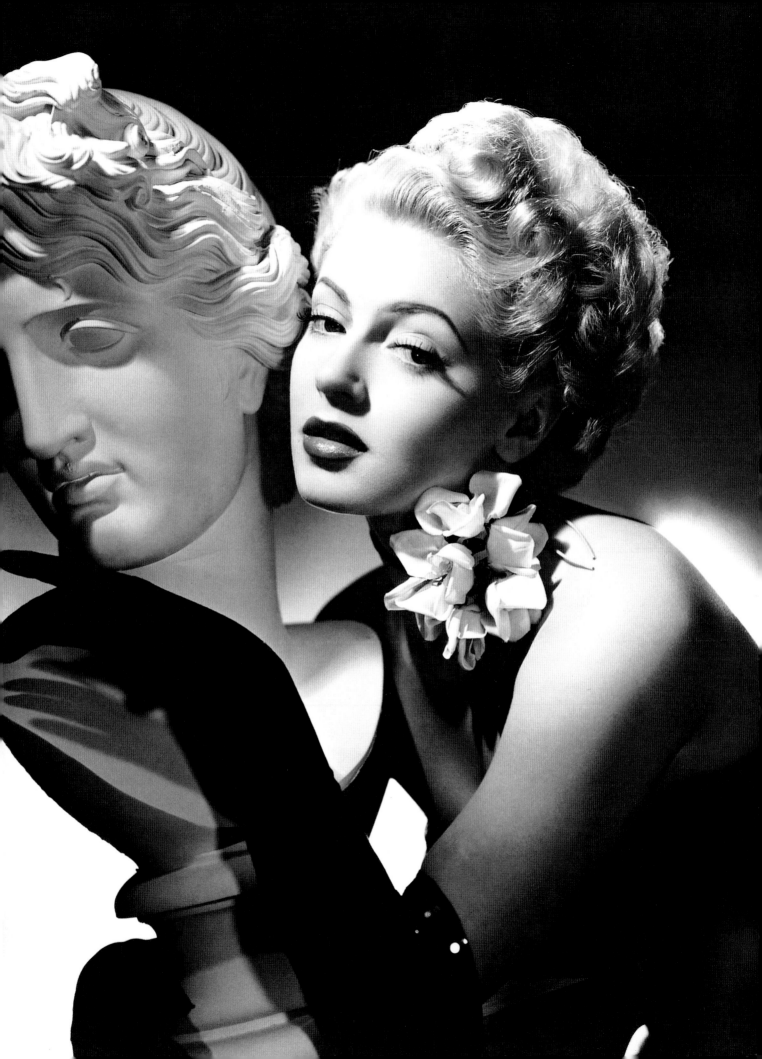

ECSTASY

Hedy Lamarr 1913–2000
Photographer: Bert Six (?), 1944
Degree of difficulty: Quite easy (3 lights)

Hedwig Eva Maria Kiesler had an admirable grasp of Hollywood essentials. As she put it: 'Any girl can be glamorous; all you have to do is stand still and look stupid.' She arrived in Hollywood in 1937, already notorious from her appearance nude in the Czech film *Extase* ('Ecstasy'). Although she made comparatively few films after that, her looks made her a star, and she was very popular.

Despite the exoticism of Ms Lamarr's outfit, and her striking looks, this is almost a textbook example of how to make the wife of the Chairman of the Board look good. The only departure from the formula is the inclusion of a little background before it fades to black.

The cropping of the (gloved) hand could be criticized, but had you really noticed before it was pointed out to you? The slightly different heights of the shoulders and the fact that the left shoulder is slightly closer to the camera – both natural consequences of the pose – are at least as important a lesson to learn: shoulders at the same height can very easily look all too much like a police mug shot.

Once again this is 'loop' lighting, with the key somewhat to camera left and the fill much closer to the camera, lower down, on the right: as so often, the catchlights in the eyes give a very good idea of where the lights are. There seems also to be a kicker, principally for the background, to camera left. The odd woolly agglomeration in the lower left-hand corner of the picture may be the remains of unsuccessful retouching designed to knock back an overly 'hot' area from this light. Otherwise, it is entirely inexplicable.

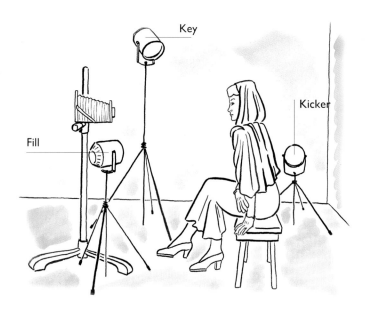

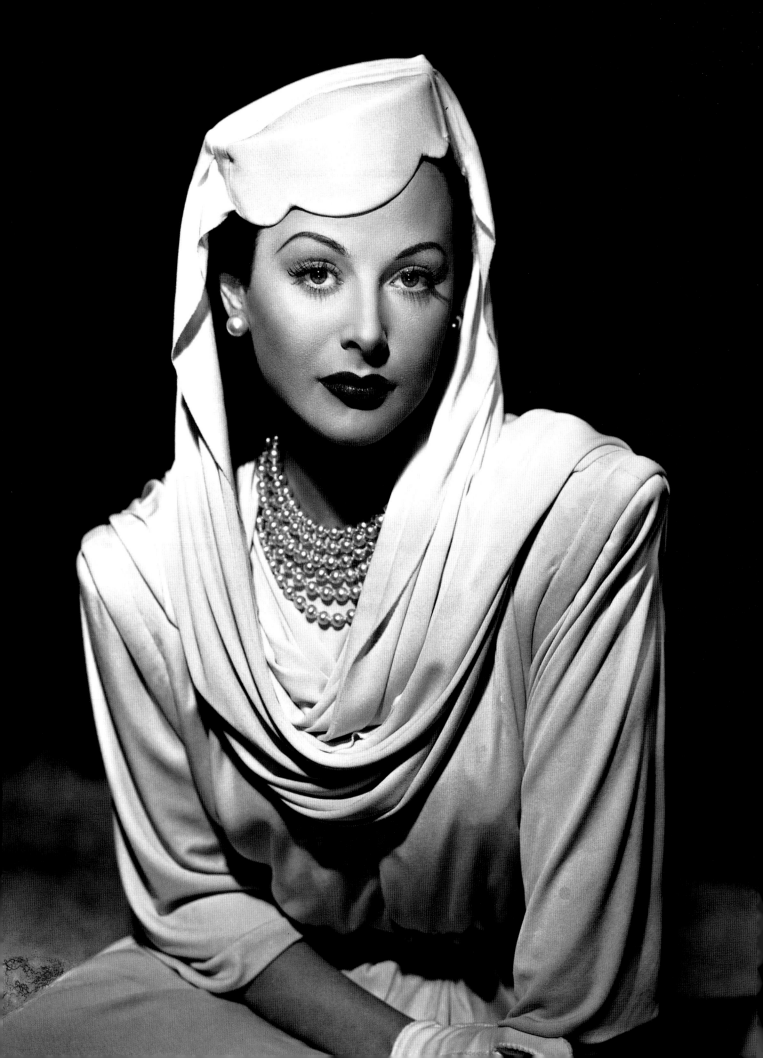

THE LOOK

Lauren Bacall b. 1924
Photographer: Bert Six, 1945
Degree of difficulty: Reasonably easy (3 lights)

The main reason for including this picture, credited to 'Scotty' Welbourne in 1946 for *Dark Passage*, is to show what can happen when retouching runs riot. The lighting is somewhere between 'butterfly' and 'loop,' seemingly without a fill; there is a backlight on the hat; Ms Bacall is at her smouldering best; and her skin appears to have been reworked with mortician's wax and a cold chisel.

Betty Joan Perske was generous in giving credit where it was due – 'What I learned from Mr Bogart, I learned from a master' – and refreshingly honest. The famous Bacall 'look,' she explained, came from being so nervous that 'I had to lower my chin practically to my chest and look up at Bogie.' She first appeared in *To Have and Have Not* (1945), and she is still acting more than half a century later, appearing in at least one film every year or two.

Purely practically, from a photographer's viewpoint, she has a wide face that is best narrowed by an astute combination of pose and lighting. Also, in those photographs where she is not looking upwards, generally slightly quizzically, her cheeks look rather long; 'the look' was definitely her best angle. Our best guess here is that the camera was slightly tilted and that Ms Bacall was also leaning somewhat. We are puzzled by what appears to be a blob of retouching on the rope to the right of the head: we can only assume that there was an unwanted hot spot that was (clumsily) bleached out in the hope that everyone, captivated by that face, would fail to notice.

Even by 1945 lighting was becoming increasingly formulaic, and we have here classic 'butterfly' lighting with the key set to give the so-called 'butterfly' shadow under the nose; the key is flagged to put the lower part of the picture into shade. The photographer appears to have relied on the robe for fill. Then there is a hair light from camera left (there may be two, but we doubt it) and finally a background light, again from camera left.

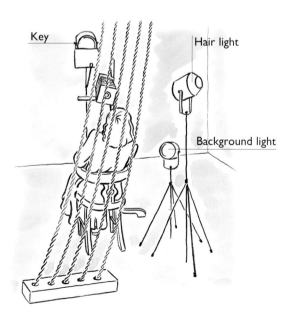

C. S. BULL

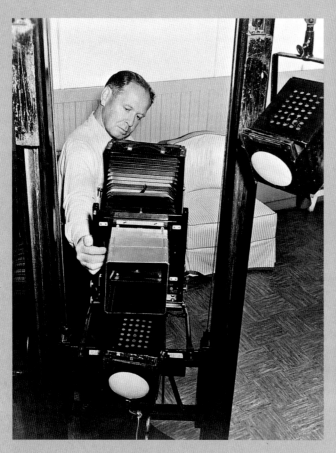

Massive twin-parallel camera stands, like the ones featured in this picture of C. S. Bull, were the rule, rather than the exception, in Hollywood. Like a modern pillar-type stand, they allow the camera to be lowered almost to ground level, or raised well above eye level, quickly and smoothly.

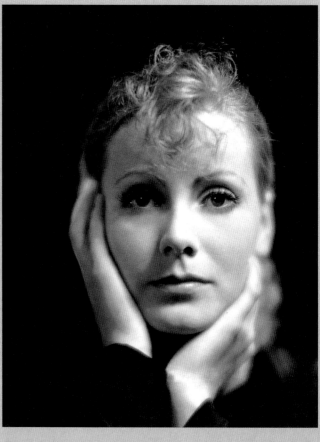

Eventually, Bull was to become Garbo's exclusive photographer, but when this picture was taken in 1930 for *The Kiss*, they had worked together only on relatively few occasions.

Clarence Sinclair Bull (1896–1979) is, for many, the greatest of the studio stills photographers, both technically and aesthetically. Others may have produced individual pictures that were better, but for consistency, range, and sheer output, he is impossible to beat. Time and again, when a picture caught our attention as we were researching this book, we found that it was one of his. Whether it was originality of vision or sheer technical quality – both of which are sometimes conspicuous by their absence in a surprising number of Hollywood portraits – Bull kept coming up trumps.

He was born in Sun River, Montana, and his interest in photography started when he was 19, in 1912.

Charles M. Russell, the Western artist, was a family friend, and it was at his suggestion that the young man bought a Kodak. Apparently, he sold bicycles and magazines in order to pay for it – travelling from customer to customer on horseback!

When he was 20, he went to the University of Michigan, and while he was there he worked at the *Michigan Daily* as a staff photographer. Then in 1918, after he graduated, he went to Los Angeles and joined Metro Pictures as an assistant kinematographer. During production breaks, he shot stills.

Bull's work attracted the attention of Sam Goldwyn, who hired him in 1920 as a stills photographer, and when Metro and Goldwyn amalgamated

in 1924, he was the first head of the stills department in the new company. A year later, of course, Louis B. Mayer Pictures joined the group, to create the company Metro-Goldwyn-Mayer.

From then until 1958, he was a staff photographer at the studio. For many years, he was Greta Garbo's exclusive photographer and shot more than 2000 negatives of her. Reputedly, the 24-year-old Garbo sat meekly through a three-hour session with the 34-year-old Bull when they first encountered one another in 1929, neither realizing that each was in awe of the other; four years later, she requested that no one else be allowed to photograph her.

Other Hollywood stars he photographed in his long career included Cyd Charisse, Gary Cooper, Clarke Gable, Katharine Hepburn, Jimmy Stewart, Gloria Swanson, and Elizabeth Taylor. The last two are particularly interesting, as Ms Swanson's links with the 'business' went even further back into the silent era than those of Bull himself, while Ms Taylor was still a star more than 20 years after Bull's own death.

Perhaps the most interesting thing about Bull's work is its sheer range. Unlike some photographers, he was both willing to experiment and technically able to make his experiments work – at least most of the time, though the retouchers sometimes went to town on his negatives. Fully dressed sets, tight head shots, the customary languid poses, shots that look like something from the nineteenth century, and shots that look as if they were taken yesterday – Clarence Sinclair Bull did the lot, without being showy, without bombast or excessive self-promotion, and with consummate skill.

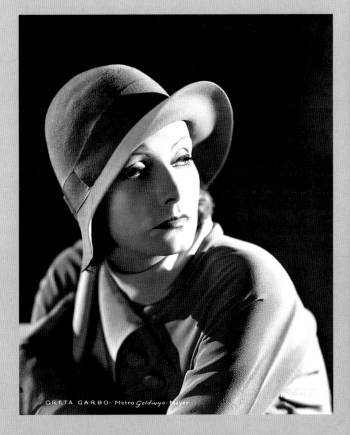

This picture of Garbo, taken for *Inspiration* in 1931 is much more dated than the one on the facing page, and well illustrates the role of clothes in fixing a picture in a particular era. The burned-out nose would be a mistake if anyone else did it: with Bull, it is high drama.

Yes, well, it's Garbo again, in 1939, for *Ninotchka*. It's not really a Hollywood portrait: it's just a very, very good picture. And it could be replicated with almost any model.

THE ROAD TO DOROTHY LAMOUR

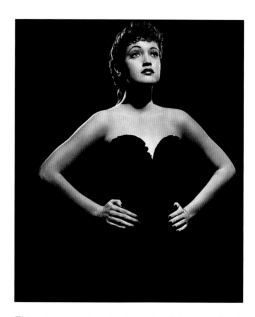

This picture, taken in 1940 for *Johnny Apollo*, is included as a tribute to creative retouching: we find it hard to believe that the bust line is reproduced exactly as photographed. On the other hand, how hard would it have been to retouch the awkward double highlight on the middle nail of the right hand? Lighting is 'butterfly,' without a fill, but with a backlight.

Dorothy Lamour 1914–96
Photographer: A. L. 'Whitey' Schafer, 1945
Degree of difficulty: Ms Lamour: easy; vase: challenging
(4 lights in all)

Devotees of the Bing Crosby/Bob Hope *Road to ...* movies will recall Mary Leta Dorothy Slaton as one of the great delights of the earlier pictures. By the time of *The Road to Singapore* (1940), she had already been typecast in 'sarong roles' and cheerfully subverted such parts without ever tipping over into parody. She continued to act into the 1970s and 1980s, though by that time with only two or three films a decade.

The lighting around the vase is frankly messy, and there are shadows everywhere – but does it matter? As ever, our attention is focused on the star, whose skin and dress are wonderfully rendered, though once you have noticed the missing right arm, you start looking for it.

There are, in effect, two separate lighting plots, one on Ms Lamour and one on the vase. We failed to agree on whether the edges of the plinth are retouched. At least some of the bright edges are the result of the lighting: whether some were drawn in is another question.

Ms Lamour is exquisitely lit with what amounts to 'butterfly' lighting: look at the nose shadow. The (scrimmed) key is somewhat to camera left, the fill fractionally to camera right. The vase is lit from camera left with two lights that cast conflicting shadows to the right of the vase, one lower and at about 45 degrees to the subject–camera axis and one closer to a side light. The fill from the lighting on Ms Lamour also casts shadows to the left of the vase in the picture, while the key on her probably acts as a fill to the side of the vase nearer her.

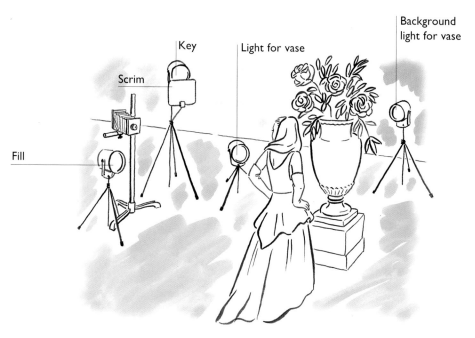

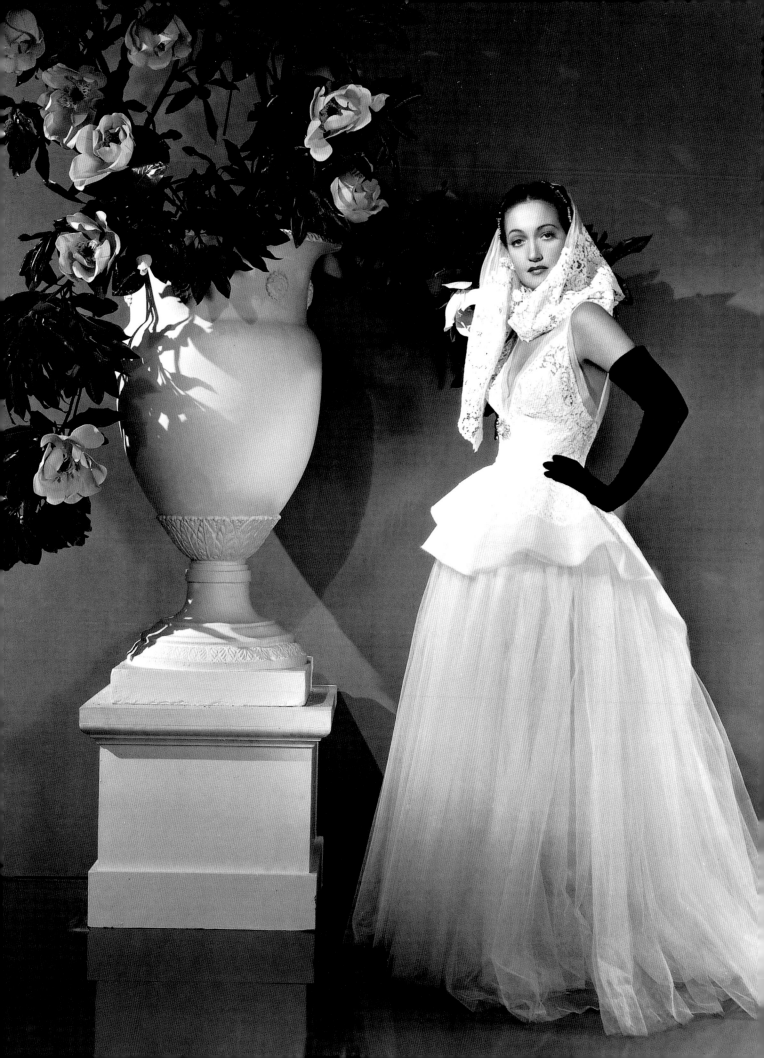

... AND TRIGGER

Roy Rogers 1911–98

Photographer: Roman Freulich (?), 1945
Degree of difficulty: Moderate (4 lights)

Leonard Slye was a star – that is to say, with his name above the title, in the old Hollywood tradition – from 1938 to 1953, frequently in the company of his horse Trigger. Singing cowboys were big box-office business in Hollywood, and Roy Rogers was almost certainly the best of the breed.

What is most remarkable about this picture is that it is a superb re-creation of daylight, probably on a sound stage. The plain, neutral background is unusual, but is presumably intended to evoke the emptiness of the prairie: certainly, the fence rail is a superb prop, conjuring up the maximum of imagery with the minimum of intrusion.

The pose is surprisingly natural, given the artificiality of the costume, and (as ever) it is fairly easy to maintain. Note how the eyes are turned away from the camera; a direct stare would have had an entirely different effect, and might well have turned an open smile into something slightly mocking. Smiles where the teeth show are harder than seems reasonable for most people to achieve naturally.

The key is a loop light to camera left, set fairly low so as to clear the brim of the hat, with a fill lower and to camera right, but not far to camera right: look at the catchlights in the eyes and the fill under the hat. The background behind the fence rail is almost certainly lit separately, by the look of it from either side: it is distinctly brighter on the right than at the center, and slightly brighter at the lower left.

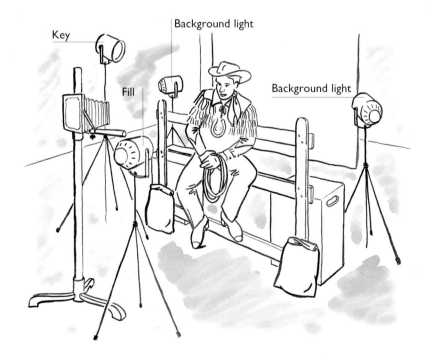

I REPRESENT THE PROLETARIAT

Gene Kelly 1912–96

Photographer: John Engstead, 1945
Degree of difficulty: Easy (2 lights)

'When Fred Astaire dances, he represents the aristocracy. I represent the proletariat.' The temptation was to headline this page 'Sittin' in the Sun,' in tribute to *Singin' in the Rain*, but the chosen quote from Eugene Curran Kelly makes two interesting points. One is that the cult of the 'regular guy' had begun to take hold even in Hollywood. The other is that he knew words like 'proletariat,' a word that many stars in Hollywood (especially in the late 1940s and early 1950s) would have hesitated to use, even if they did know it.

This seems to be an 'improved snapshot.' Mr Kelly's natural grace would quite conceivably lead him to sit like this; a set photographer would see it; and in the days of roll film cameras, it would take but a few moments to fill overly dark shadows and take the picture. If the photographer had had to haul in an 8 x 10 in. camera, the picture might well never have been taken. Nevertheless, the artless pose does rely on Mr Kelly's looks and grace. Diehards will bemoan the fact that his socks do not cover his calves; that the perspective is not as pleasing as if a longer lens had been used (our guess is that this was shot on a Rolleiflex); and that his right shoe disappears awkwardly into the shadows, with only the white parts showing.

The light appears to be daylight, from a window to camera right, the frame of which is on the far right of the picture. It is supplemented by another light to camera left, conceivably another window, but, from examination with a magnifying glass of the catchlights in the eyes on the original print, it was more probably a portable fluorescent lamp. There is also a slight highlight from this fill on Mr Kelly's forehead.

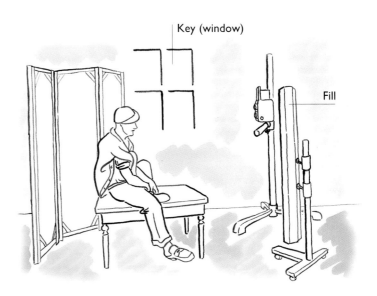

Key (window)

Fill

MAKE THEM BELIEVE IT

This picture, from *Indiscreet*, was shot in 1958. Of course Ms Bergman is older than in the picture opposite, but the loss of glamour is not attributable to a mere dozen years. Rather, it is the photographic style; she is no longer a 'star,' in the style of the 1930s and 1940s, but merely another very attractive woman.

Ingrid Bergman 1915–82
Photographer: Not credited, c. 1946
Degree of difficulty: Fairly easy (4 lights)

'It's not whether you really cry. It's whether the audience thinks you are crying.' Ingrid Bergman made them believe it, despite what was a somewhat cavalier attitude to the 'business.' After several Swedish films she moved to Hollywood in 1938, became a star, moved back to Europe to be with Roberto Rossellini in 1948, and then became a Hollywood star all over again after her return in 1956.

The camera probably is not tilted; the fall of the hair argues that the head really was tilted. For a real Hollywood look, incidentally, hairstyling (even a makeover) may be essential: many female stars had flowing locks, and male stars used so much pomade that we coined a term for a particular type of backlight, a Greasy Hair Light.

The portrait is, overall, reasonably timeless and does not carry too many dating clues in make-up or dress. One thing that identify it as of its time is the extremely shallow depth of field. The chiaroscuro around the face, illuminating a light mid-tone against dark mid-tones and textured shadows, is masterful.

The lighting is formulaic 'butterfly' plus fill, with the key slightly to camera left and the fill just about alongside the camera on the right: look at the catchlights in the right eye. The line differentiating the chin is almost certainly the result of light reflected up from the dress. There is also a hair light, and the background appears to be separately lit: otherwise, the band of shadow that helps to differentiate Ms Bergman's face from the background would be much lower.

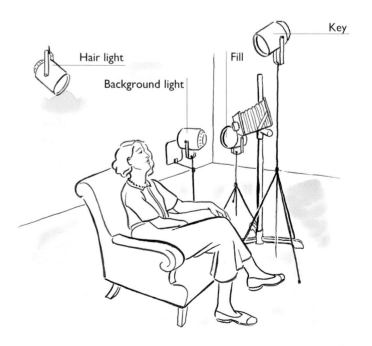

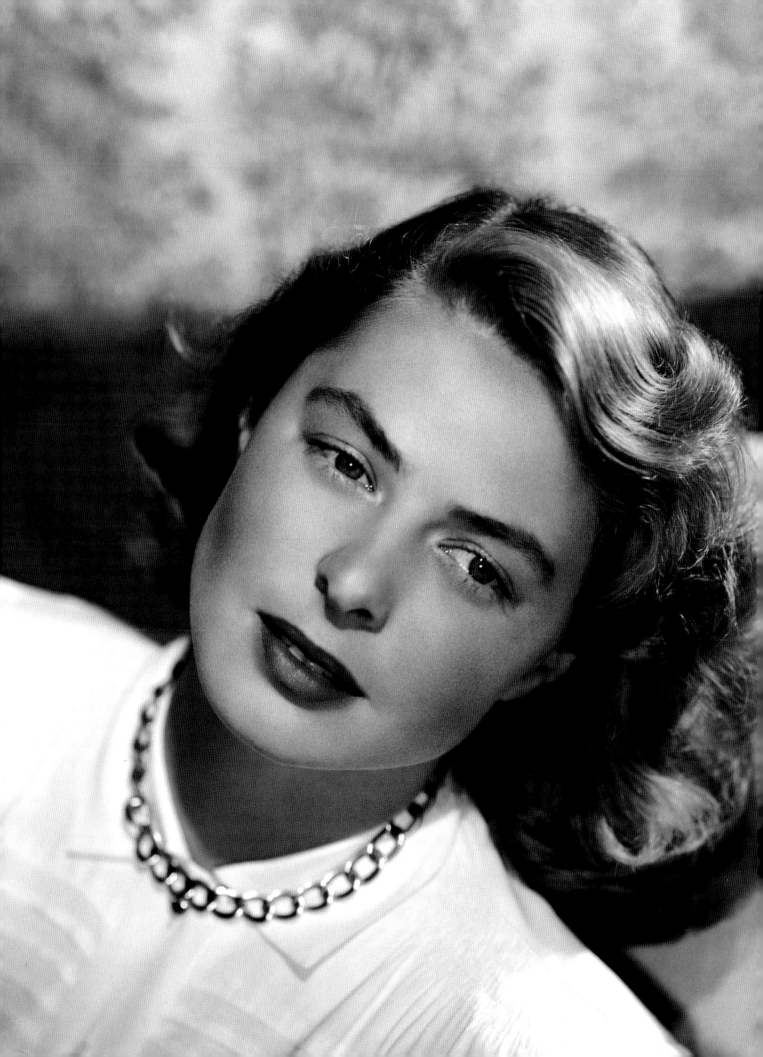

PEEK-A-BOO

Veronica Lake 1919–73
Photographer: E. R. Richee, 1947
Degree of difficulty: Fairly hard due to the fill (5 lights)

It is true that many Hollywood stars deprecated their talents prettily, but Constance Frances Marie Ockleman deserves an award for: 'You could put all the talent I had into your left eye and still not suffer from impaired vision.' She also deserves some praise for her taste in names. Even if she was not the world's greatest actress, she was certainly one of the world's most beautiful models. She might even have made it as Constance Ockleman.

Ms Lake was as noted for her hair as for her legs, and both are celebrated here, though unusually, we can see both eyes: very often, she was photographed with one eye more or less concealed by a drape of hair, the 'peek-a-boo bang' as it was (perhaps unfortunately) named.

The lighting on Ms Lake's face is something between 'butterfly' and 'loop,' and the hair light is clear enough: in fact, there may well be two hair lights, which is what we have drawn. The real fascination in the lighting here lies in the fill. Although there may be more than two lights, the classic approach would be to use just two arranged in 'wraparound' style. Here, the one on camera right is probably higher (look at the shadows and highlights on the right knee), while the one on the left is at a slightly more acute angle to the subject and mounted rather lower. The photographer has fully exploited the reflective properties of the light-colored clothing, to create a high-key figure against a black background and to bounce light wherever it is needed.

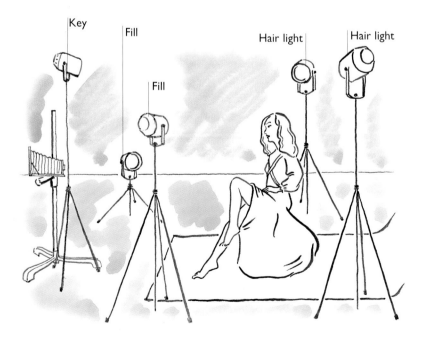

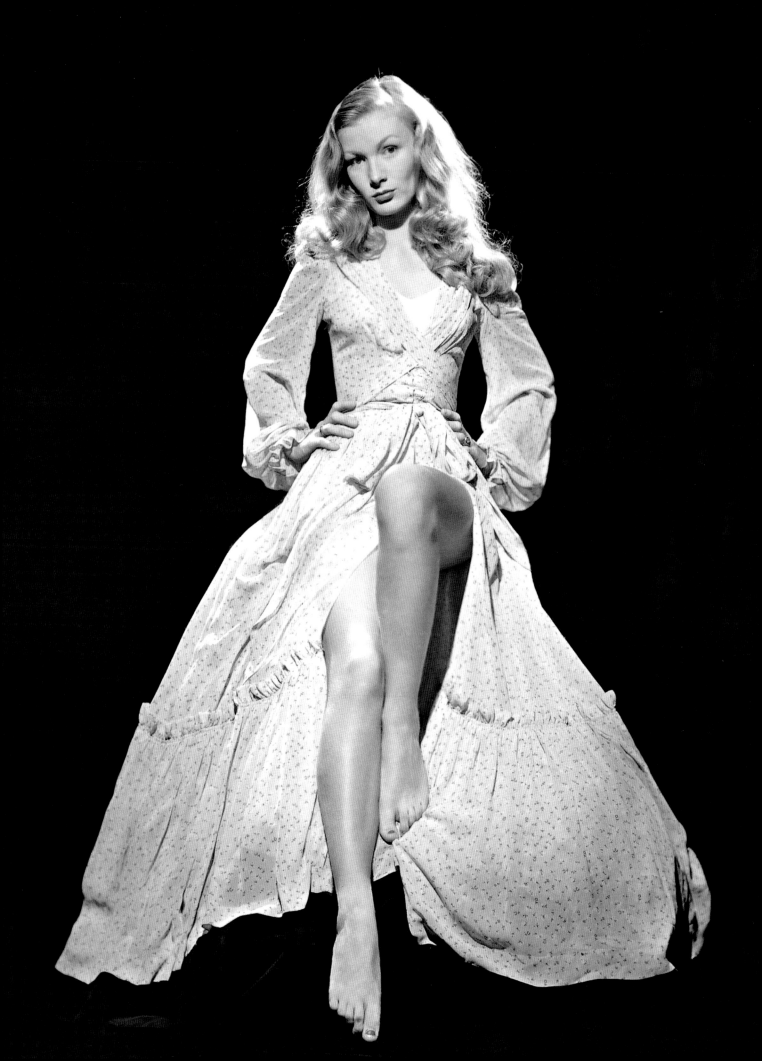

EVACUEE

Dame Elizabeth Taylor b. 1932
Photographer: C. S. Bull, 1948
Degree of difficulty: Surprisingly easy (2 lights, maybe more)

Little Elizabeth Rosemond Taylor was evacuated to Hollywood during the dark days of World War II. Her first film appeared in 1942, and she was a star at the age of 12 with *National Velvet* (1944). In her late sixties she was still 'bankable,' and the media reported her private life in a manner hardly less breathless than was the fashion of the 1930s.

This portrait owes a certain amount to William Mortensen, who advocated very flat lighting, with the contrast boosted by extended development, though its tonality is to a considerable extent the result of its being a conversion from a colour original. While we are not sure how this portrait was achieved, we are reasonably confident that it could be reproduced in the fashion we have drawn – and that may have been the way that it was actually shot. In the original print, though it may not hold in reproduction, the hair is well differentiated from the background.

The key is extremely soft, probably because it is all indirect. A big white bounce, directly beside Ms Taylor, could be lit with one or more powerful spots: we have drawn only two, though three or even four would be entirely feasible. Another bounce to Ms Taylor's right (camera left) would provide a small amount of fill: if it were at the right angle, this could account for the rather bright right ear and shiny earring. Everything in the picture, including the background light and the shadow on the right shoulder, could be achieved with one single light used as described – though retouching has almost certainly helped.

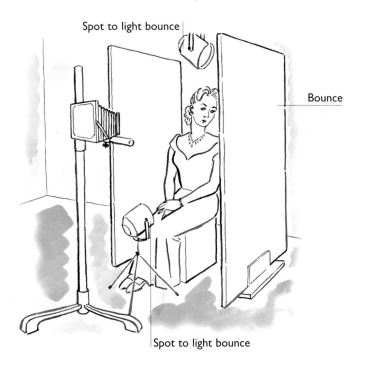

Spot to light bounce

Bounce

Spot to light bounce

SOMEHOW, I MAKE IT

James Stewart 1908–97
Photographer: Not credited, 1949
Degree of difficulty: Easy, apart from the set (2 lights)

James Maitland Stewart was at his best playing, in his own words, 'the inarticulate one who tries. I don't have all the answers, but for some reason, somehow, I make it.' He also said of himself, 'I don't act – I react.' He was first nominated for an Academy Award in 1939 (*Mr Smith Goes to Washington*), and in 1940 he won an Academy Award for *The Philadelphia Story*. He also picked up three other Academy Award nominations, and in 1984 he was given a Special Academy Award 'for 50 years of meaningful performances.'

This would seem to be an 'improved candid,' rather like the picture of Clark Gable on page 47: a picture that was seen, improved in both lighting and pose, and then taken with an 8 x 10 in. camera. Sitting sideways on the chair is a good way to add variety, anchor the left hand, and support the pose overall: if you look through this book and at other books of Hollywood portraits you will note that sitting squarely and neatly in a chair, the way we were told to sit in kindergarten, is the exception rather than the rule.

The background in the lower left is most easily explained as the corner of a 'cove' where there is a smooth curve between one wall and the floor to remove the wall/floor boundary and create an 'infinity curve.'

The lighting on Mr Stewart is pure 'butterfly': fairly high and pretty much in line with the nose, at around 45 degrees to the subject–camera axis. There does not appear to be any fill, but there may be a bounce to camera left, and there is a hair light to camera right. The background appears to be lit by spill from the key.

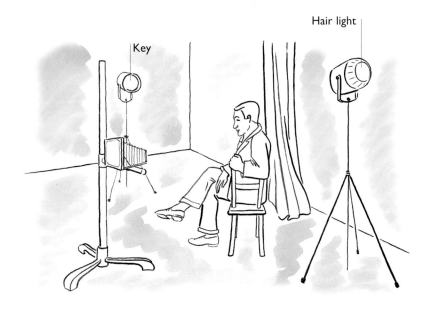

THE FIFTIES

GRACE KELLY

This 1954 picture of Grace Kelly, taken by Bud Fraker for *Rear Window*, shows that the style of earlier eras persisted well into the 1950s: the tilted camera, the exquisite skin-tones, the almost non-existent shadow detail, the 'loop' light. There is a lack of attention to detail: a grass stalk makes a kebab of Ms Kelly's head, and the breast shadows are bizarre. Only the subject's compelling beauty redeems the picture.

THE FIFTIES

Bud Fraker again, and a much more modern 'reportage' shot than the one of Grace Kelly (left). It will not be apparent in reproduction, but a curious thing about this 1956 picture of Yul Brynner is that nowhere is it critically sharp – though the disembodied left arm and chopped-about hand will be all too obvious. this is definitely not in the tradition of the 'dream machine' of earlier decades.

The dividing line between the 1940s and 1950s is by no means clear-cut. By the late 1940s there were more and more still photographers in Hollywood who were using 4 x 5 in. and 6 x 6 cm roll film – but equally, there were those who continued to shoot 8 x 10 in. well into the 1950s and even in a few cases into the 1960s. By the mid to late 1950s too, color was becoming more and more important. Although this often meant a return to larger formats, particularly 5 x 7 in., in order to get good quality, it was a far cry from the black-and-white work of the earlier decades.

In black and white, the smaller formats meant that retouching was more difficult, but this did not necessarily matter. The whole style was growing more informal, closer to reportage. To be sure, there were still grand set-pieces like the picture of Virginia Mayo on page 41, and even the roll film portraits were in many cases a lot less casual than they seemed, but the perfect 'screen god' or 'screen goddess' no longer seemed to be the ideal. Now, the stars were portrayed more approachably: as men and women out of the ordinary certainly, but much more akin to the fans who went to see them.

All of this fitted the mood of the 1950s. World War II was over, and standards of living – not just in the United States, but also in the apparently defeated Axis countries – were increasing as never before. The war had meant the destruction of social and geographical barriers. People had mixed with strangers from all over the globe: filmmakers could still pander to prejudices, but they could not get away with the stereotypes that they had used in the past.

Blatant escapism, such as the musicals, could be presented in a stagy, almost cartoon-like form, without any real attempt at creating three-dimensional characters, but when the stars stepped down from their painted South Sea islands, they were expected to revert to being something akin to normal human beings. The sheer, unadulterated, elegant style of film noir, on the other hand, had become much grittier and more realistic, and Stanislavsky's 'method' acting, with its reliance on 'emotional memory,' had an enormous influence on stars who had had little or no formal training in the craft of acting but still wanted to be taken seriously as actors. Only the epics demanded a grandeur, a sort of *faux*-realism, a scale as large as the recently finished war itself. Besides, the end of the 1950s would see a new sort of star, the pop star, whose adulation would exceed anything that the silver screen had seen since the days of Valentino.

The changes in the style of movies, the changes in the style of acting, and the changes in the equipment used to make the portraits all meant that the 1950s saw the end of the classic monochrome Hollywood portraiture. There would still be many great pictures; but they were no longer Hollywood portraits, or even Hollywood-style portraits, and so the era would end.

I COULDA HAD CLASS

Marlon Brando b. 1924
Photographer: John Engstead, 1951
Degree of difficulty: Fairly easy (3 lights)

'I coulda had class, I coulda been a contender,' mumbled the young Marlon Brando, Jr., in *On the Waterfront* (1954), which brought him his first Academy Award after being nominated in 1951, 1952, and 1953. Almost 20 years later, in 1972, he found himself up against himself for Academy Awards in two movies: *The Godfather* and *Last Tango in Paris* (*The Godfather* won). As he grew older, critical acclaim grew more mixed: everyone agreed that he had a monstrous talent, though they sometimes differed in their use of the word 'monstrous.'

The 'hot' light on the nose and lip is, to coin a phrase, a 'sneer light.' Combine it with his left eye disappearing almost completely into menacing shadow, and you have the epitome of a young tough, lounging against a lamppost. For a more conventional effect, either the light would be pulled back a little, so as not to strike the nose, or Brando would have been asked to turn his face slightly more towards the camera. The T-shirt could hardly be used to advertise washing powder, but deliberately 'punk' clothing should always be treated with caution: too much grubbiness and ripping can distract attention from the subject, and artificial dirtying can look all too obvious.

The key is high and to camera left, as evidenced by the shadows of the brow, nose, and chin; the hair appears to have been flagged off. A broad, flagged backlight from camera right lights the hair, the left arm, and, of course, the left temple, nose, and lip; this is the 'sneer light' mentioned above. There does not appear to be any fill, but the background is separately lit.

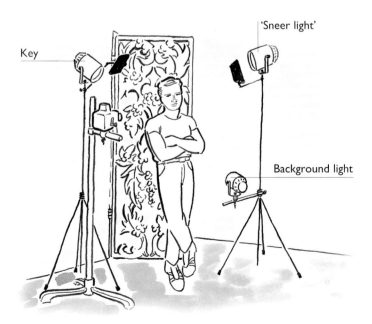

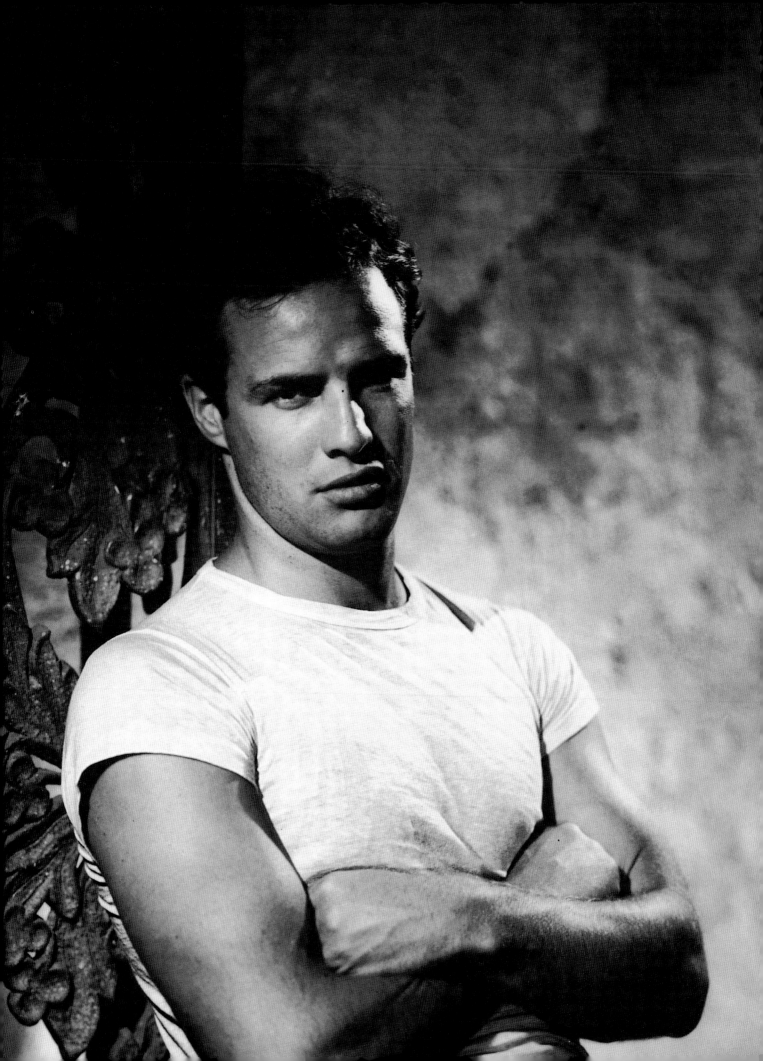

TWO GOOD REASONS

Jane Russell b. 1921

Photographer: Gene Kornman (?), no date
Degree of difficulty: Fairly easy (3 lights)

In the words of Howard Hughes, who gave Ernestine Jane Geraldine Russell her first starring role (*The Outlaw*, 1943): 'There are two good reasons why men will go to see her.' In this picture, a more mature Ms Russell reminds us that she also had a very striking and lovely face.

The camera is probably tilted, so that in the original scene Ms Russell's head was upright. This trick of tilting the camera allows the stars to look calm and elegant, rather than strained or slumped.

An interesting aspect of this picture is its timelessness: it could be re-created with almost anyone in a roll-neck sweater, and it would seem as fresh and original as this must have when it was first printed. The absence of jewelry and the simple hairstyle mean that the picture is not dated at all. The make-up is perhaps the only drawback: the lips have been outlined a little too heavily to look natural but a little too lightly to look contrived. There may be a tiny bit of diffusion, but it really is very slight, and it would be reproducible with a weak Softar or other high-quality soft focus screen on roll film. Alternatively, a cheap zoom might work well on 35 mm.

The lighting is straightforward 'loop,' with the key high and fairly well to camera right, and the fill just to camera left and somewhat lower. The catchlights from both are visible in the eyes. A backlight makes up the lighting trinity, illuminating the hair and part of the collar – though something that is not immediately obvious is that the wool of the sweater changes color at the top of the neck.

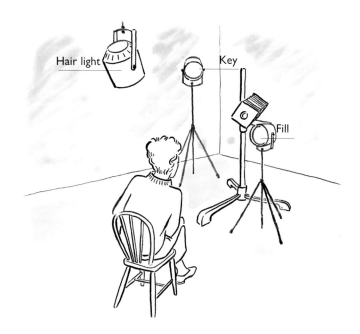

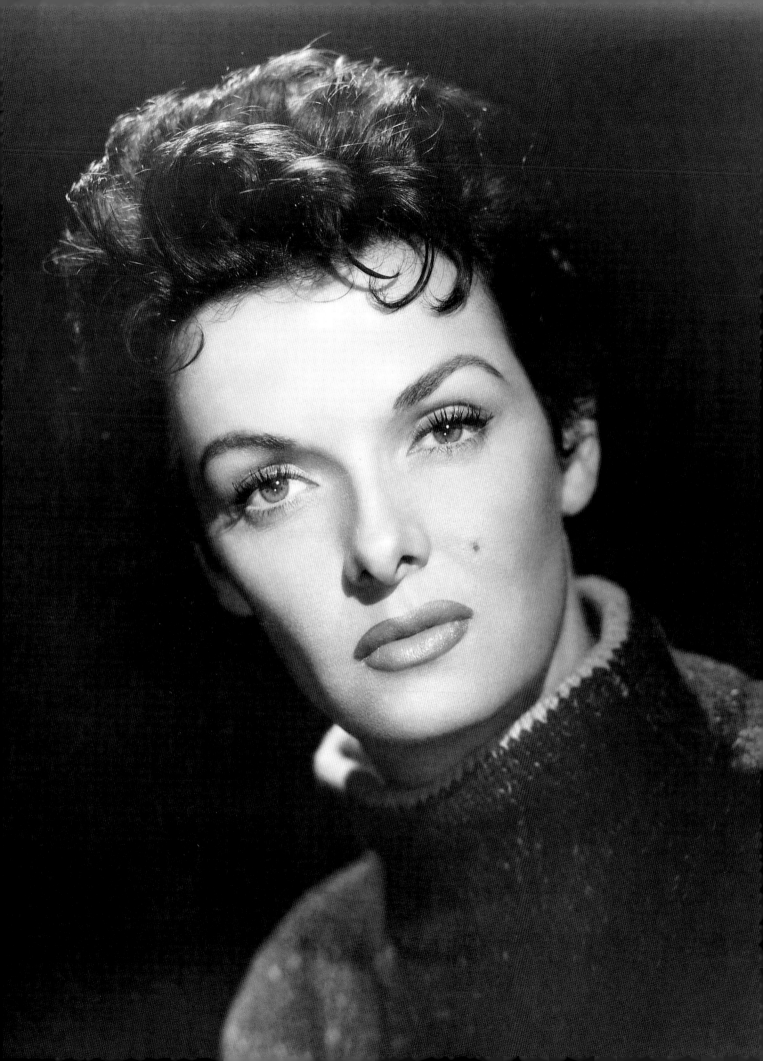

DANSEUSE

Cyd Charisse b. 1922
Photographer: C. S. Bull, 1953
Degree of difficulty: Easy, if you have the space (4 lights)

Tula Ellice Finklea is one of those minor stars whom few recall in a particular movie, but almost everyone recalls for herself, albeit not under her given name. This might actually be a surer indication of stardom than many others.

As so often, the melodramatic standing pose (in particular) requires a very attractive model or careful draping or (as in this case) both to make it work. In the 1930s Gerhard Riebicke's photographs of nudes were often in equally contorted poses, and awkward wrinkles and folds are commonplace in his work, even with slender models.

The lighting in both pictures appears to be identical, despite the very different poses and the fact that Ms Charisse is facing in opposite directions. This is an excellent illustration of the point that what creates apparent variations in lighting is as often the pose of the model as changes in the actual lighting. It also explains how so many provincial photographers could get away with 'brass-stud' photography, with the positions of their two or three stock lighting set-ups marked in the floors of their studios with brass-headed tacks.

The lighting in both pictures almost defies belief, coming as it does from four directions simultaneously: Ms Charisse is in the middle of an X of light, coming pretty much symmetrically from camera left and camera right. Three – left rear, right rear, and right front – are set low, and the fourth, left front, is set higher. There may also be separate background lights, though spill from the two rear lights could also do it. On analysis, there are too many shadows going in too many directions; but who analyzes pictures so carefully?

Arguably at her finest and most athletic in the 1940s, when she was in her twenties, Ms Charisse remained a strikingly lovely woman throughout the 1950s and beyond; and age did not seem to weary her legs, which, if anything, compelled the eye even more than the rest of her.

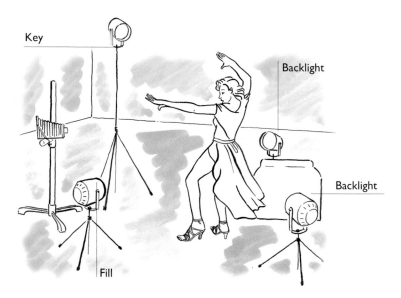

SILVER-SCREEN GODDESS

By the time Ms Monroe was 'discovered,' Hollywood photography had moved away from 8 x 10 in. cameras to 4 x 5 in. and even roll film. Although the pictures are superficially the same, the tonality is different from the pictures taken with the big cameras, and the bokeh (the quality of the out-of-focus image) is very different. This was shot by Frank Powolny in 1952.

Marilyn Monroe 1926–62
Photographer: Frank Powolny, 1953
Degree of difficulty: Surprisingly easy (3 lights)

In her early twenties, Norma Jean Baker was renamed Marilyn Monroe after signing a $125-a-week contract with 20th Century-Fox; she became a star at 22 with *The Asphalt Jungle* and *All About Eve.*

For many, she is the definitive screen-goddess-cum-sex-symbol, and most of the appeal of this picture reflects this: the less-than formal attire; the half-closed, knowing eyes; the leaning forward as if to impart a secret or to be kissed. The plane of focus is the hand, which is heavily retouched to lighten it, so that it is almost divorced from Ms Monroe herself. The lips are barely in focus, the eyes plainly unsharp. But maybe this hazy, dazed view is the way that most men saw (or would like to have seen) her; and the hand could almost be that of the onlooker. This is a surprisingly easy picture to re-create – at least from a lighting point of view. Either spots or snooted flash would create the key and backlights satisfactorily, with a soft box (or failing that, an umbrella) as a weak fill.

The lighting is classic Hollywood: formulaic, perhaps, but effective. The key is the feathered edge of a very high, soft spot from camera right, fractionally behind the subject, but almost at 90 degrees to the subject–camera axis. Another spot, from camera left, backlights the right shoulder and just adds a tiny amount of highlight to the right hand. A strong fill, pretty much above the camera, creates quite hot highlights on the face, especially the lips, nose, and forehead.

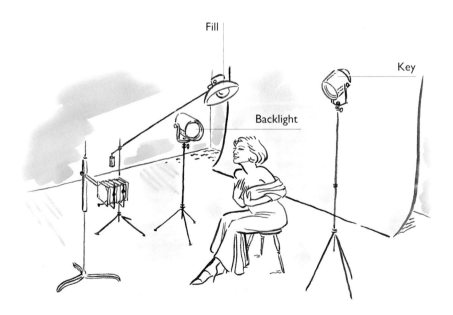

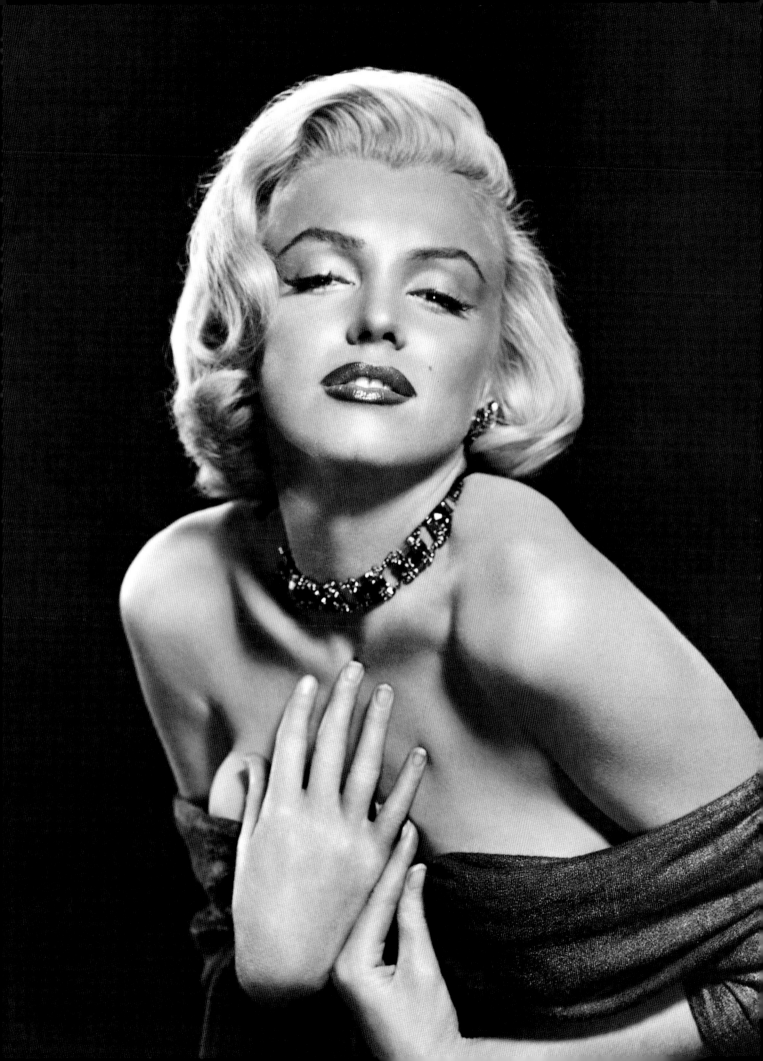

PLAYING SONS OF BITCHES

Kirk Douglas b. 1916

Photographer: Not credited, 1954
Degree of difficulty: Fairly easy (4 lights)

Issur Danielovitch reckoned that he had 'made a career of playing sons of bitches,' but he was hardly fair to himself, or, if he was being accurate, he played a surprising range of sons of bitches with some conviction, from Vincent Van Gogh to Spartacus.

The camera is almost certainly tilted; in other words, this is a normal, vertical pose and if you place the upper left corner of the picture above the lower right corner, you will see how Mr Douglas was standing. When examined closely, the pose is a bit of a fraud, even apart from the tilted camera. If he were really pulling on that rope, especially at that angle, his muscles would stand out more; this sort of thing is worth thinking about when you set up this kind of shot, in which reality is slightly misrepresented. Carry it too far – which does not seem to have been done here – and it can be too obvious.

It is also worth remarking that he is probably looking slightly to the right of the end of the rope. If he were looking straight at it, his eyes would show more white. Checking things like the whites of the eyes soon becomes second nature in portraiture, but at first, it is something you have to think about consciously.

The key is pure sidelighting from somewhat high to camera right – the camera is tilted, remember – plus a fill, low on camera left, and two backlights from camera left (though it might just be possible to do it with one). The hottest highlight on his right shoulder is slightly too hot, and the left side of the face and neck are bright, but not too bright: backlights can often be more dramatic than seems feasible.

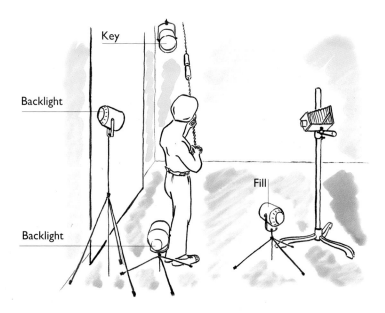

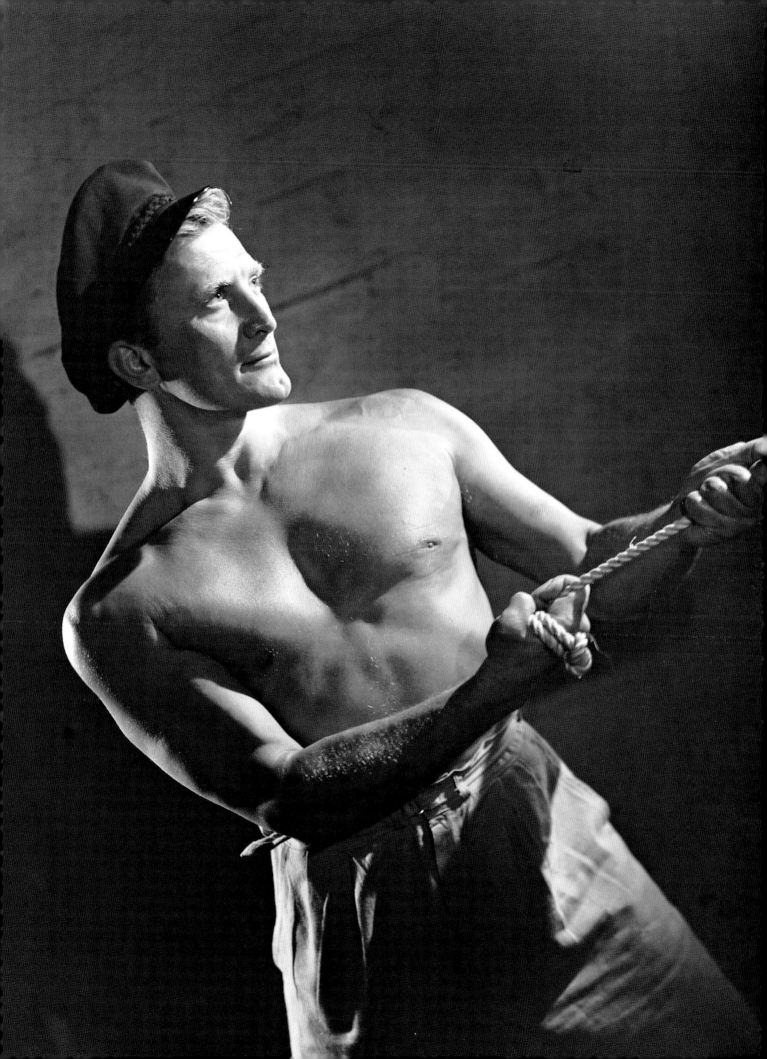

ONE WILD OAT

Audrey Hepburn 1929–93
Photographer: Bud Fraker, 1956
Degree of difficulty: Fairly easy (3 lights)

The first film in which Edda van Heemstra Hepburn-Ruston appeared, in 1951, was *One Wild Oat*, a curiously touching description of her tomboyish and innocent sexiness. Watching for her in the Ealing comedy *The Lavender Hill Mob* (1951) is one of the many pleasures of a delightful movie. Her rise to stardom was more than confirmed by *Roman Holiday* (1953), for which she won her only Academy Award – though many would have given her another for *Breakfast at Tiffany's*. Her last appearance, only a few years before her death, was in *Always* (1989).

In the original print, the slightest trace of a shadow can be seen on the black background, though it probably will not show in reproduction. The effect could probably be duplicated with black seamless paper and minimal exposure; this also helps to render the texture and chiaroscuro of the white outfit, though it does render the skin tones rather darker than would normally be thought appropriate. A good solution would be to use black flocked paper or black velvet.

A small point worth noting about the costume is that the tied ends of the cummerbund break up what would otherwise be an awkwardly large area of rather dull tone. It would be extremely interesting to try to re-create this in color.

The lighting is almost 'copy lighting': a pair of lights, symmetrically disposed on either side of the camera, to light both sides at 45 degrees. This would normally give a double nose shadow, and there is a trace of this on the right side of Ms Hepburn's face. In this setup the key is set high and to camera left; the other light, lower and to camera right, is somewhat weaker. There is also a hair light.

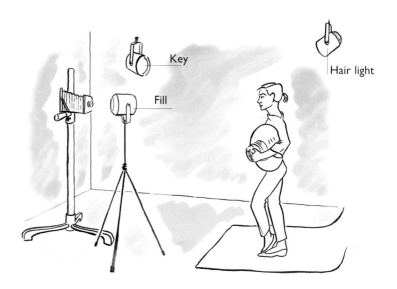

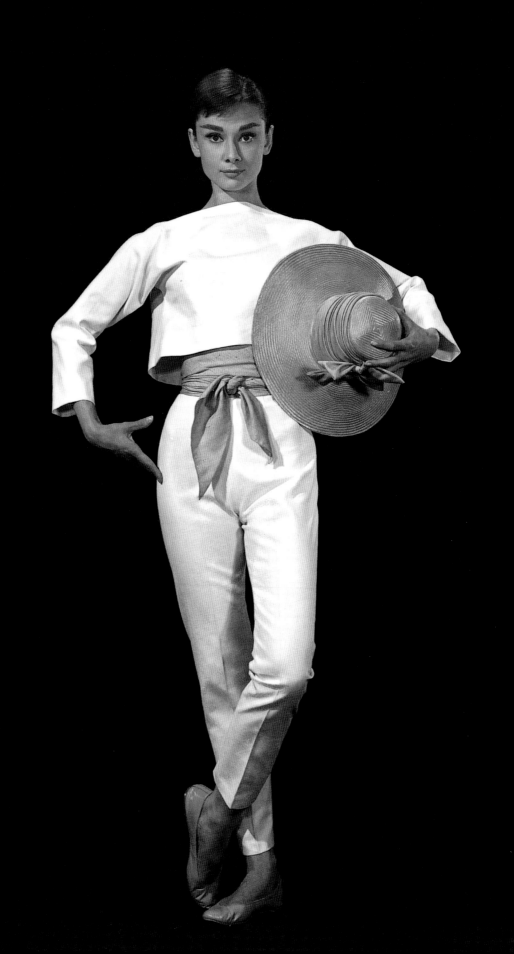

WHAT PEOPLE THINK YOU'VE GOT

..

Sophia Loren b. 1934
Photographer: Not credited, 1958
Degree of difficulty: Challenging (about 6 lights)

Sex appeal, said Sofia Scicolone, is fifty percent what you've got and fifty percent what people think you've got. She might have added that it helps if you change your name – and that many people would be delighted with even ten percent of what she has got.

Technically, this is one of the weakest pictures in this book. The pose is awkward, and there are conflicting shadows and burned-out areas all over the place. It is also a textbook illustration of the difficulty of rendering a dark dress and a light sofa simultaneously.

The lighting is even less desirable than the pose. Look at the two conflicting nose shadows and the overlit, out-of-focus, burned-out cigarette. On her face, there is both 'butterfly' and 'loop' lighting, a classic example of two conflicting would-be keys, and the two chin/chest shadows are hardly any better: one shadow comes from the loop key, and the other from a light almost directly above, but slightly behind. Disregarding Ms Loren's face – which is never easy – this latter light could be taken as the key in a figure study, as it all too clearly determines the shadows in the rest of the picture.

This above-and-behind light is probably the same one that burns out the cigarette and the front of the couch, and over-lights Ms Loren's left torso, though from the highlight on the left elbow, there is a fill there from camera right. Then, the shadow on the upper side of the right leg and the highlights on her right ankle argue for another fill to camera left, and low. And finally, there is a background light.

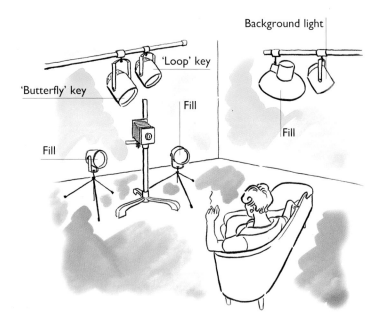

Background light

'Loop' key

'Butterfly' key

Fill

Fill

Fill

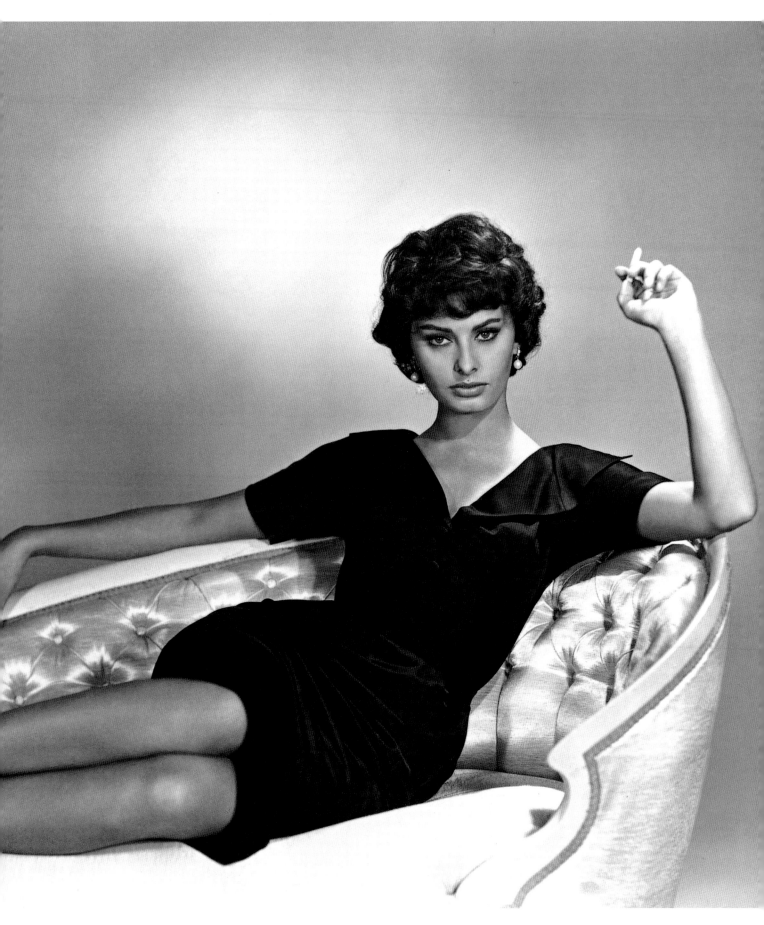

... AND ROCK AND ROLL

Elvis Presley 1935–77
Photographer: Virgil Apger, 1959
Degree of difficulty: Challenging (6 or more lights)

This portrait of Elvis Aron Presley, though iconic, bears little resemblance to the Hollywood style. Don Siegel compared Elvis Presley with Rudolph Valentino. Both had qualities of personal magnetism that went beyond the explicable; and this takes us back to the whole nature of what constitutes 'star quality' and of how this rare characteristic can be communicated by moving or still pictures.

This is a more pensive picture than even that of Marlon Brando on page 127, and it is achieved as much by lighting as by the pose. Mr Presley is much more wrapped in light than was Mr Brando, and the whole effect is softer and gentler. To be hypercritical, the hand is too big in proportion to the face, because the picture was almost certainly shot on a Rolleiflex with a fixed 80 mm lens; but to be more positive, this shows just how wide a lens you can use and still get a very pleasing effect.

The key is a broad light from camera right, modelling the nose, lips, and chin. There are two fills: one beside the camera, the other low and to camera left. You can infer the latter from the shadow on the wrist. There is a hair light above and behind Mr Presley and slightly to camera right. One of us thought that a backlight, from camera left, put more modelling into the right sleeve; the other thought it was spill from the background. There are probably two background lights – that's five or six – and there appears to be a completely inexplicable sixth or seventh light that casts the barely visible upper shadow of the ear, in front of the lobe and below the sideburns.

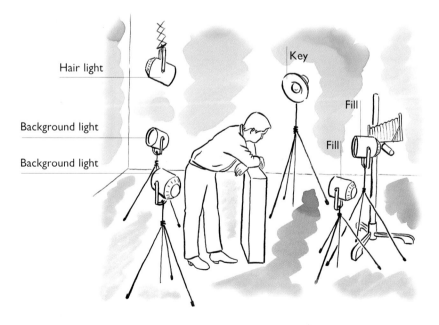

Hair light

Key

Fill

Background light

Fill

Background light

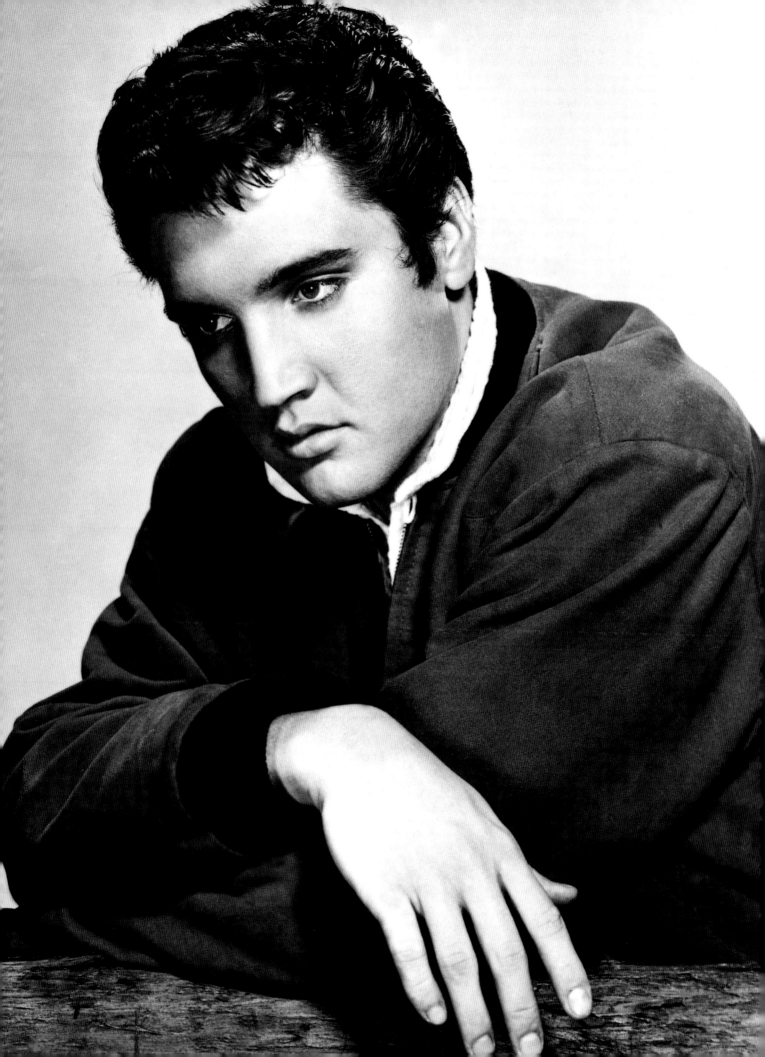

INDEX

ACKNOWLEDGMENTS

Our greatest thanks must go to Frances Schultz, who should really be credited as a co-author, so much did she contribute to the book. We would also like to thank Mr Michael Parker, Vice-President of Mole Richardson Lighting Equipment of Hollywood, for his kind assistance with clarifications regarding some of the lighting terms of past and present. Any mistakes are not theirs: we must blame each other.

PICTURE CREDITS

Most of the portraits that appear in this book were produced for publicity purposes by the Hollywood film studios. Where possible we have identified the photographers and the studios. We apologize in advance for any unintentional omission or neglect and will be pleased to insert the appropriate acknowledgment in any subsequent editions. We would also like to thank Phil Moad for his patience in tracking down some hard to obtain information. And John Kobal for starting it all.

Charles Chaplin: 144; Columbia: 90(r), 95, 98; Fox/20th Century-Fox: 5(t), 57 (*20,000 Years in Sing Sing*), 77, 108 (*Johnny Apollo*), 129, 132, 133 (*How to Marry a Millionaire*); Goldwyn: 41; Metro/MGM: 5(b), 8(b), 9, 10, 14, 16(b), 21, 27 (*Young Rajah*), 32, 35, 36, 37, 42 (*Inspiration*), 43 (*Mata Hari*), 45, 47, 49 (*Letty Lynton*), 50, 51, 52, 53, 70, 73, 83, 93 (*Waterloo Bridge*), 101, 106(l), 106(r) (*The Kiss*), 107(l) (*Inspiration*), 107(r) (*Ninotchka*), 113, 115, 119, 121, 130 (*Sombrero*), 131 (*Sombrero*), 141; Paramount: 17, 20, 28, 29, 30, 31, 33, 55, 58, 59, 61, 63 (*Tonight Is Ours*), 65, 67, 69, 79, 90(l) (*This Gun for Hire*), 109 (*Masquerade in Mexico*), 124 (*Rear Window*), 125, 137 (*Funny Face*), 139; Republic: 111, RKO 16(t) (*Christopher Strong*), 71, 75, 91, 97; United Artists: 11 (*Suddenly*), 85 (*Stagecoach*), 117 (*Ramrod*); Universal 12 (*The Killers*); Walt Disney: 135 (*20,000 Leagues Under the Sea*); Warner Bros: 2, 5(m), 7 (*Rebel Without a Cause*), 8(t), 10(t), 13, 40, 81, 86, 87, 99 (*Casablanca*), 103 (*The Conspirators*), 104 (*Dark Passage*), 105, 114, 127.